THE LIFE OF A STEAM RAILWAY PHOTOGRAPHER

THE LIFE OF A STEAM RAILWAY PHOTOGRAPHER

The Reverend Alan Newman

COLIN G. MAGGS

AMBERLEY

This book is dedicated to the Reverend Alan Newman —
a delightful, helpful and most generous friend.

First published 2010

Amberley Publishing Plc
Cirencester Road, Chalford,
Stroud, Gloucestershire, GL6 8PE

www.amberley-books.com

Copyright © Colin G. Maggs, 2010

The right of Colin G. Maggs to be identified as the Author
of this work has been asserted in accordance with the
Copyrights, Designs and Patents Act 1988.

British Library Cataloguing in Publication Data.
A catalogue record for this book is available from the British Library.

ISBN 978 1 84868 826 1

Typesetting and Origination by FONTHILLDESIGN.
Printed in the Great Britain.

Contents

The author first met Alan Newman over 60 years ago when Alan courted and married the daughter of Colin's piano teacher. They re-met in the compartment of a train returning from the 150th Anniversary of the Rainhill Trials, Colin helping him to eat his sandwiches. Alan has proved most helpful in providing illustrations for Colin's books.

Chapter 1

The Reverend Alan Newman Catches the Railway Bug

What could be more exciting for a small boy than to move to a house with a busy railway at the bottom of his garden? However the story should start at the beginning.

Alan Newman was born on 12 October 1918 within sight and sound of the GWR station at Bath and lived there for the first few years of his life. When he was four, his elder brother and a cousin acquired a taste for collecting names of GWR locomotives and Alan recalls youthful voices shouting out such grand names as *Bride of Lammermoor, Knight of the Golden Fleece, Saint Gabriel* and *Polar Star*. It was about this time that he remembers his first railway journey to Bristol and Weston-super-Mare.

About three times a year the family ventured out on a day excursion to that watering place. He well remembers the grubby locomotive, usually a Mogul or a Bulldog just about ready for an overhaul at Swindon. Being only an excursion the train had low priority and there was a crescendo of angry comment when it was placed in a siding at Bedminster — for congestion at Bristol was rife and track quadrupling there was very much in the future.

Whenever Alan's family climbed to the platforms of the Bath GWR station, one of the three 2-4-0Ts seemed to be present — No 6, 967, 977. There was also a 0-6-0PT which worked Westmorland Goods Yard where there stood a little locomotive shed with enough room for two. Another 'shunter' kept in the station yard, came in the shape of a horse, which, among other duties, used haul coal wagons into the electricity generating station, while a further duty was to move the daily slip coach from the down Main line to the Middle Road.

Alan recorded his sightings in a penny notebook. He observed 49 Dean Goods 0-6-0s and a dozen Aberdare class 2-6-0s which he found attractive because of their peculiar appearance. One solitary Barnum, No 3211 appeared in his records, though he saw others. 2-4-2T No 3614 was certainly the only one of its class he ever saw in the area. In the middle twenties, the 4-4-0 classes were around in considerable numbers. The 41XX series (Atbara, Badminton and Flower) figured largely and of the 73 members of the class, as many as 42 graced the pages of his little dog-eared notebook. He saw at least half of the twenty-strong City class and the appearance of No 3710 *City of Bath* always raised a cheer from his group, while *Lyttelton, Mauritus* and *Malta* raised a groan because they appeared so frequently. Most of these observations were made from the very attractive Sydney Gardens which the railway passed through in a highly scenic setting.

The County class was much in evidence while Bulldogs were two-a-penny. Apart from No 3288 *Mendip*, Dukes did not appear quite so frequently and thus were

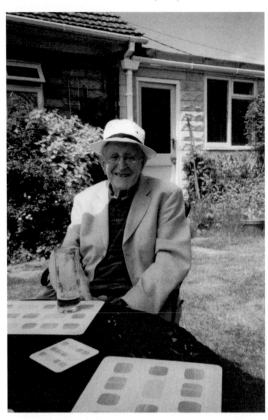

Left: The Rev Alan Newman in a friend's garden, 2007. Photo: Ron Hurst

Below: 8750 class 0-6-0PT No 9665 at Bath GWR station, 9 May 1949.

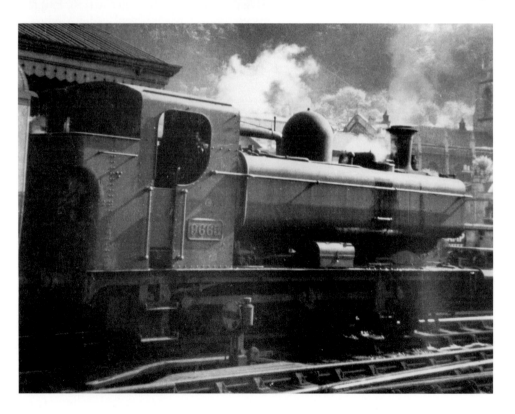

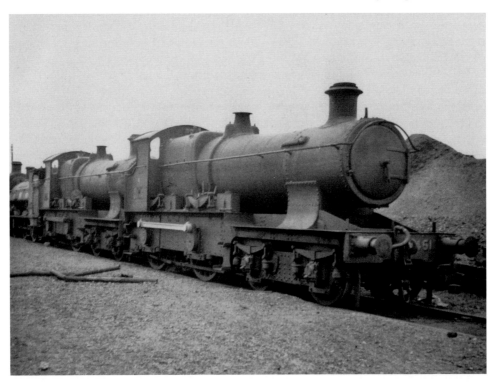

Withdrawn Bulldog 4-4-0 No 3451 *Pelican* and No 3447 *Jackdaw* on the Dump, Swindon, 13 July 1951. Behind the Bulldogs is No 1952, one of the few 0-6-0 tank engines which remained as a saddle tank until withdrawal in April 1951.

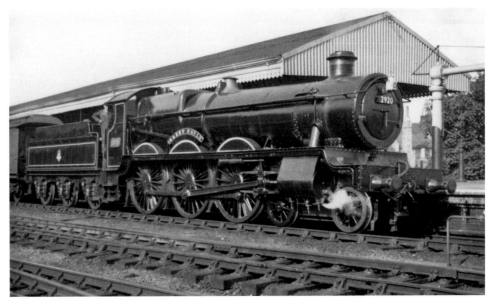

Ex-works Saint class 4-6-0 No 2920 *Saint David* at Bath 14 September 1951 working the Up morning running-in turn. It was the last Saint to be withdrawn.

favourites. As for the 4-6-0 classes many could be seen in quite a short time. Castles were being constructed and Alan has a vivid memory of the brand-new *Caerphilly Castle* pulling out of Bath on the evening test run to Swindon. He saw *The Great Bear* only once, his father holding him on his shoulders in the street below in order to give him a better view.

In the autumn of 1924 came a really tremendous event — his first journey to Paddington on a family visit to the British Empire Exhibition at Wembley. It was rather a lot for someone of his tender age to comprehend. First there was Swindon 'crawling with locomotives', though his mother and grandmother tried to help his brother extract something from the mass of material all around. "*Cape Town:* have you got that? *Charles Saunders* over there. *City of Gloucester* over here. *Hercules,* that's an unusual one." It was an impossible task.

The journey onwards from Swindon left him in a kind of stupor and it was perhaps with a sense of relief that he emerged from the seething activity of Paddington and was taken upstairs on a primitive-looking General bus.

The following year the family covered the same ground again and one incident stood out in his memory. They caught a train from Wembley to Marylebone. It was dark, and Alan was extremely tired and half carried along the platform where they came to the engine at the buffer stops. It was black and not green. The word 'Great' was on the tender and what followed it did not appear to take the familiar shape of 'Western'… it surely could not be something else! His tired eyes must be blurred, that must be it! Then he became aware of a completely new phenomenon which shook him out of his somnambulant state. This 'Great something-or other' was actually puffing and yet it remained static. He had no knowledge of the Westinghouse brake pump — the GWR did not go in for such things.

In the years that followed an occasional trip to the capital occurred. A cheap return from Bath after midday cost only five shillings. Between Reading and Paddington the County 4-4-2Ts were a common sight. While several examples of the odd-looking inside cylinder 3901 class 2-6-2Ts were seen; they had been converted from Dean Goods 0-6-0s. Among the smaller engines working in the London area were the 633 class 0-6-0 side tanks Nos 633/4, 641/2/3. All these interesting specimens had disappeared by the mid-1930s having been ousted by the arrival of the new large Prairies.

In May 1927 the Newman family moved from the centre of Bath to what was then the western outskirts. Immediately beyond the bottom of the large garden lay the territory of the former Midland Railway, recently having become part of the LMS. Until that moment, the Midland, despised as it was in the opinion of those around him, had remained a closed book. Alan had been brought up to regard the Great Western as the only railway system worthy of his attention, so perhaps in a revolt against this tradition he set out to interest himself in this other line.

As it happened he needed little encouragement. The first specimen to arrive at the bottom of his newly-acquired garden was a red 2-4-0, a clean, neat little job, with a new sound and a new smell. She bore 92 in large numbers on the tender — much more interesting that a small cab-side plate As Alan watched her go slowly by and with the steam gushing from her Salter safety valves blowing across his face, he knew that his affections had undergone a dramatic change. He found it difficult to sleep that night for his new bedroom window overlooked the railway and to make sure he did not miss anything, was jumping up and down like a jack-in-the-box. It was just like having a conjuror's hat out of which came surprise after surprise.

The Midland Jumbo became one of his favourite classes of locomotive and in later years he made a point of looking up the few remaining specimens. No 219, by then

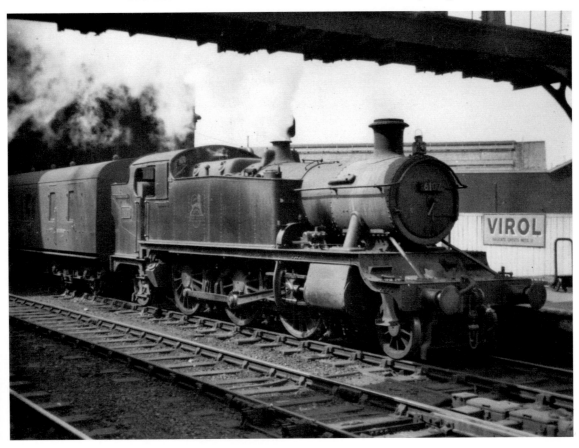

Large Prairie No 6107 at Bristol Temple Meads working the 1.00 p.m. to Avonmouth via Severn Beach, 21 April 1955.

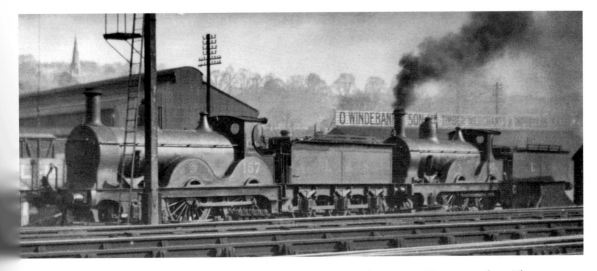

Two members of Alan's favourite class of locomotive at Bath in 1934: Nos 157 and 92. These were the last representatives of this class to be shedded in the city.

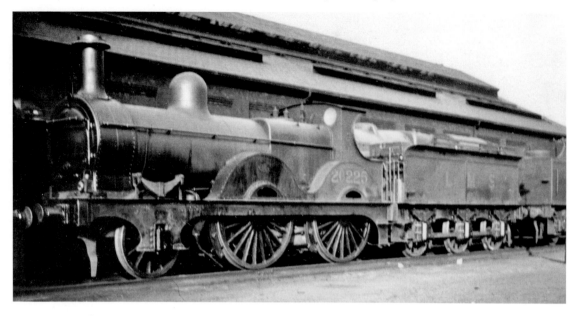

Ex-works 2-4-0 No 20225 at Derby, 8 August 1937.

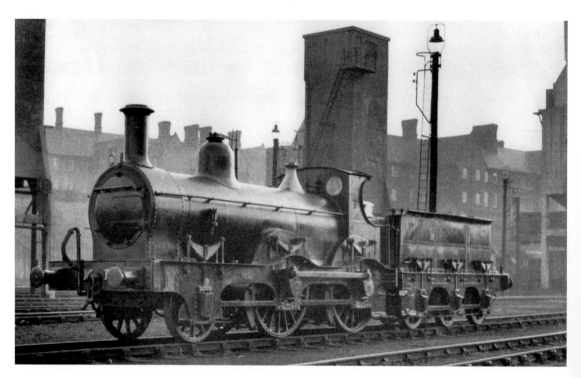

MR 2-4-0 No 158A at Leicester in restored condition, 26 February 1968.

20219, was his last recorded entry. She was found in Nottingham shed on an August day in 1937. In 1927 Bath had Nos 92, 155 and 157 engaged in local passenger duties, whilst others seen were Nos 90, 104, 122 and 164. No 92 remained at Bath for many years and it was while still in store there that she received her new five-figure number 20092 — on 17 January 1935, Alan actually watched it being changed. No 157 was scrapped shortly after the outbreak of WW2, but No 155 went on to become 'Engineer South Wales' and was not withdrawn until 1950. In all he was able to record the arrival of some thirty Jumbos in Bath over the years. Not a large number, but representatives of the class rarely showed up from depots beyond Gloucester except in the height of the summer season when they could be seen piloting a Class 2 4-4-0.

Among those summer pilots came several double-framed examples — Nos 1, 2, 8, 18 and 19. Saltley and Derby provided most of this motive power, though he well remembers when No 142 arrived with a 20 shed plate — Buxton. His last recorded visit of a Jumbo to Bath bears the date 18 March 1940 when No 20008 arrived with the Walsall Engineer, but looking all wrong with a Stanier chimney. She is now happily restored to her original condition as MR No 158A and Alan was fortunate enough to be able to point his camera at her as she sat on the turntable in Leicester shed in February 1968.

In the late twenties Alan was the proud owner of a Hornby train set with an LMS 0-4-0T. Then in a toyshop window he saw LMS 4-4-0 No 2441 for a pound — a price well beyond his pocket. Eventually a kind grandmother gave him the required sum and was able to purchase the engine and eventually saved a further 3s 6d to buy the tender. In a spare room his father erected trestles for the railway. His brother owned a GWR 4-4-0. Alan later bought a second-hand Bing 4-4-0 in LNWR livery and painted it red. He augmented his locomotive stock further with a Hornby No 1 Special 0-4-0T in LMS livery. His brother added a Compound 4-4-0.

Alan viewed his very first ex-LNWR locomotive in Bath of all places! No 5014 *Murdoch* slipped unobtrusively in and out of the city one day in 1930, pulling and pushing an engineer's saloon from Walsall. He got little more than a passing glimpse, but caught enough of the distinctive North Western wheeze which became so familiar to him a few years later. The only other LNWR engines he saw in Bath were Cauliflower

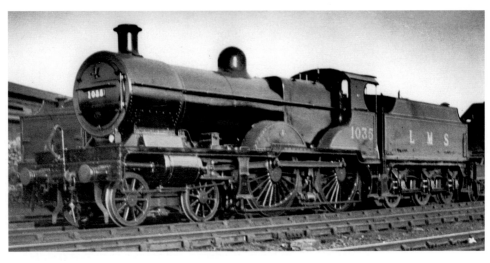

Resplendent in red livery is ex-works MR Compound 4-4-0 No 1035 at Derby, 8 August 1937.

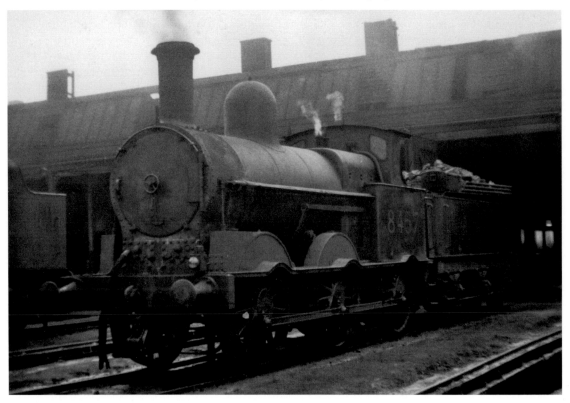

LNWR Cauliflower 0-6-0 No 8457 at Crewe South, 22 August 1938.

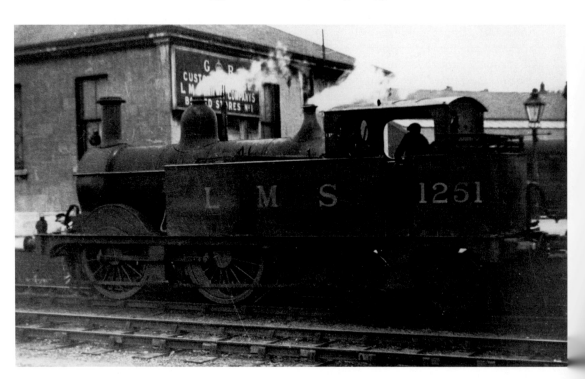

Class 1P 0-4-4T No 1251 at Bath with an S&D train, 16 July 1936.

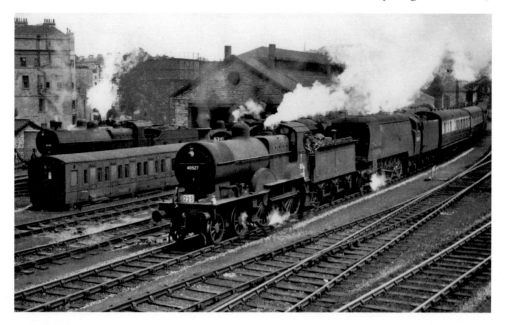

A Sheffield to Bournemouth train leaves Bath 31 July 1954 behind 2P 4-4-0 No 40527 and West Country class Pacific No 34093 *Saunton*.

0-6-0 No 8594 bringing in a crane from Walsall on a Sunday afternoon in April 1937, and an unidentified G2 0-8-0 standing outside the old Midland shed towards the end of WW2.

Commuter traffic between Bath LMS station and Bristol St Philip's was in the hands of Johnson Class 1 0-4-4Ts, robust little engines that could really show their paces between stations. In 1927 those which worked regularly in the area were Nos 1334/7/8/9, 1364, 1380/7/9, 1390/7 and 1404. As with the 2-4-0s, this type became one of his favourites, though they were more ubiquitous than the 2-4-0s and could be found in most corners of the system. A fair number survived into Nationalisation, some of the last to function being at Highbridge, but with their BR numbers they seemed so different. No 58077 could never convey the same feeling as No 1397. It is surprising what a number and a style of lettering did to a locomotive.

Alan was sad when the powers-that-be ordained that LMS numbers be carried on the cabside and the large tender numerals discontinued, though the latter could certainly be confusing at times: he remembers seeing 3F 0-6-0 No 3591 with the tender of No 3807. Another sad feature of the late 1920s was the phasing out of red on some classes hitherto painted thus. The 2-4-0s, 0-4-4Ts and Class 2 4-4-0s began to appear in unlined black, though the situation was redeemed a little by the use of attractive shaded numerals and lettering.

Alan discovered that there were two high spots in the day's activities — the Pines Express, Up from Bath at about 12.30 p.m. and Down to Bath about 2.30 p.m. He would rush through the house at lunch time, hotfoot from school, doors banging, mother scolding, and sped down the garden path to catch a glimpse of it. In the late twenties and until the introduction of larger types between Mangotsfield and Bath, this turn was the preserve of a Midland Class 2 4-4-0 usually from Saltley, though a Derby, Gloucester, or Bristol engine could be involved, such as Nos 490-529. Only once did he record an engine other than a 4-4-0, when, on a sultry summer afternoon in 1929,

MR Class 3F 0-6-0 No 3213 leaves Bath 14 May 1936 with a freight to Gloucester.

S&D Class 3F 0-6-0 No 43228 on the turntable at Highbridge, 22 August 1951.

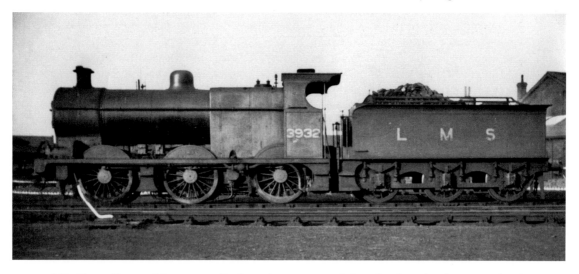

MR Class 4F 0-6-0 No 3932 at Derby 8 August 1937. It has the short-lived sans-serif style lettering.

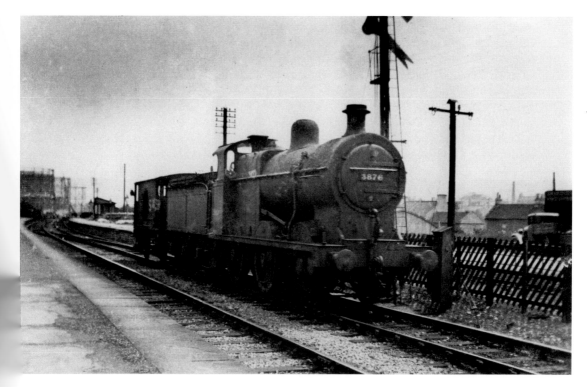

MR Class 4F 0-6-0 No 3876 passing Weston (Bath) station, 26 May 1936.

the Down Pines staggered in very late behind Class 4 0-6-0 No 4332, then shedded at Wellingborough.

Another regular Class 2 working was that which came into Bath every day at 4.15 p.m. invariably worked by a Gloucester engine. For weeks the sole performer was No 527 in immaculate red livery with the appearance of a present day preservation society. Standards of cleanliness were not normally as good as this, but rarely did he see anything approaching the filthy locomotives of later years.

Regarding the freight scene Alan recalls the Kirtley Class 1 double-framed 0-6-0 which gave the impression of great age — and certainly in the twenties this type was indeed quite old, dating back to the 1860s. These engines were used on local pick-up goods and their leisurely shunting activities in the nearby coal yard, timber yard and brewery siding gave Alan the time to stand and stare at these venerable machines. Nos 2471, 2576/94/96, 2609/10/65 and 2752 formed the stud at Bath and Bristol, but had been withdrawn by 1932. No 2752 was of particular interest as she bore a plate above the cabside number relating to her exploits in France with the Railway Operating Division in WW1.

Another particularly interesting train was the daily run from Saltley nearly always with a Class 3 0-6-0 in charge, arriving at Bath at 8.30 a.m. and returning at 9.10 p.m. Saltley shed was well supplied with Class 3 engines and they were excellent performers. He noticed no less than fifty of them 1927-30. Sometimes a stray from Derby or Burton on Trent would appear, but this was very much the exception. A few Saltley Class 2s appeared on this turn, but seemed to struggle with what was a reasonably heavy assignment.

Class 4 0-6-0 Nos 3840/1/73/4/5, 4125/6/34/5/69/70, 4276/7/8, 4535/6 were at Bristol and were more concerned with mixed traffic than purely freight duties and it was most unusual to see a Class 2 or 3 0-6-0 on a passenger turn. At this period Class 4s made their way into Bath on another duty. On Fridays and Saturdays, and sometimes mid-week in July and August, the Pigeon specials came in behind engines from an incredible variety of depots, even from places like Crewe, Stoke on Trent, or Newton Heath, as well as from most of the Midland depots in the north and north-west. These specials were a source of great delight for many years and 5.00 a.m. on a summer morning would see him at his bedroom window waiting for the procession to start. The Midland goods yard at Bath would be jam-packed with pigeon traffic — as well as a lot of pigeons who seemed not to be interested in flying home.

Chapter 2

Alan's Railway Experience Widens and he Begins Railway Photography

Until 1928 Alan remained ignorant of a third railway at Bath, then, one day in the early summer of that year an aunt took his brother on a day trip to Bournemouth and he returned with tales about blue engines. A couple of months later he took Alan to a spot near Bath Junction where the Somerset & Dorset crossed the Lower Bristol Road. There he waited with the thrill of expectation for his first sight of a locomotive in blue livery.

As it happened the first object to come into view was a coal wagon, then another, then a plume of steam and then — well, the propelling locomotive could hardly be called blue. It was an extremely grubby specimen, albeit a most fascinating one. Appropriately enough it was S&D No 1, a Fox Walker 0-6-0ST of 1874. After depositing the wagons in a bakery siding a short distance up the line, No 1 returned to her duty of shunting the gasworks sidings and banking up the 1 in 50 gradient to Combe Down Tunnel.

The appearance next of No 68 was obviously, even to Alan's inexperienced eye, a Midland Class 2 4-4-0 in different guise. She was nicely turned out and really blue, as were the rest of her class when he first knew them. Nobody had told Alan about the S&D 2-8-0s so he was quite unprepared for the sight of one. No 90 came rumbling over the road bridge, a veritable mountain of a locomotive, or so it seemed, despite his acquaintance with the GWR Class 28XX 2-8-0s. No 90 was one of the later 1925 series and then only three years old. So began Alan's long association with this remarkable class. At first running into Bath on freight turns only and always tender-first because of the short turntable there, he viewed them some thirty years later being used on passenger work on summer Saturdays.

The smaller S&D 4-4-0s presented an interesting variety and were in and out of the city daily. Nos 14 and 15 with their domes nudging their chimneys, were his particular favourites. On 1 January 1930 the S&D locomotive stock was absorbed into that of the LMS. Alan was quite unaware of this, so when he saw a blue 4-4-0 standing outside the Midland station that spring bearing the number 302, he cycled the rest of the way home from school greatly wondering. The following day at the same time he passed the station again. This time No 301 was there and he recognised it as his old S&D friend No 15. The subsequent weeks were great fun, with the S&D engines appearing with their new numbers, all of which had been locally hand-painted with an artistry of doubtful quality in not a few instances.

It was the S&D which offered Alan his first experience of a railway disaster, or rather the aftermath of one. On 20 November 1929, 2-8-0 No 89 and her train ran out of control from Combe Down Tunnel and crashed in the goods yard at Bath. He was only eleven at the time and a day or two after the accident, managed to push his way through a group of trespassing sightseers to gaze on the massive pile of wreckage with

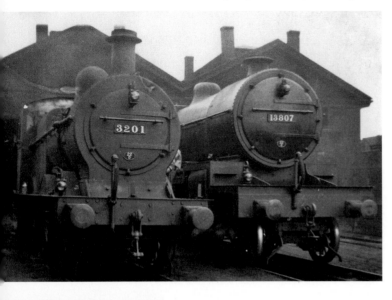

S&D 0-6-0 No 3201, a Templecombe engine, and S&D 2-8-0 No 13807 at Bath, 28 May 1936.

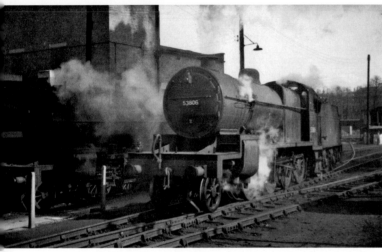

Left: Class 7F 2-8-0 No 53806 at Bath 19 March 1955. The photograph was taken shortly before a smaller boiler was fitted.

Below: Blue-liveried S&D 4-4-0 No 301 at Bath 1931.

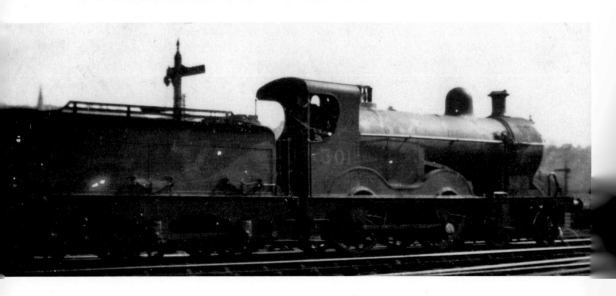

MR 1F 0-6-0T No 1870 at Bath in 1931. For some years it was the resident shunter. The sliding cab roof is open.

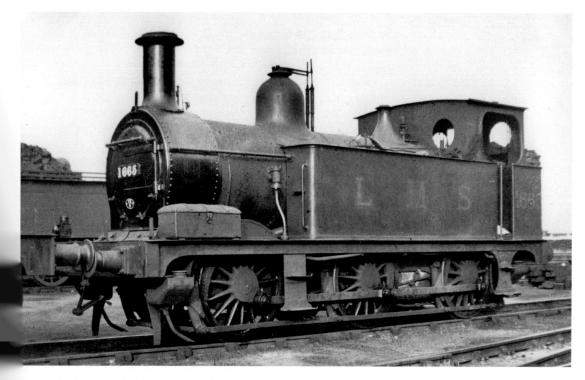

MR 1F 0-6-0T No 1665 at Bedford, 9 August 1936.

No 89 lying on her side just visible. It was a spectacle that had the morbid fascination of disaster and remained embedded in his memory. No 89 was repaired and returned as LMS No 9679 fitted with a smaller boiler.

In the autumn of 1928 Alan staked his claim on an observation point where he could view both the S&D and Midland locomotive sheds, look down towards the passenger station and keep watch on all the freight sidings. Countless hours of sheer joy were spent there with book and pencil, with the whole scene made all the more delightful being set against the backcloth of the beautiful city of Bath.

Although on one or two occasions he was rebuked for trespassing, generally the railway staff were a friendly lot and on several occasions he was invited on to the footplate. When helped into the cab of S&D 2-8-0 No 81 for his first ride he felt very small, very awkward and very hot. Later on he spent a whole morning on the footplate of 0-6-0T No 1667, the shunter working the Midland goods yard.

During 1927 a Horwich Crab 2-6-0 appeared for trials on the S&D. Imagine Alan's incredulity when, as he watched a midday freight headed by a Saltley Class 3 0-6-0 labour past the house one day with the red beauty No 13064 in the middle of the train. His immediate reaction to this spectacle was that it was some new invention from a foreign source — like the Ljungstrom-Beyer-Peacock turbo locomotive, photographs of which he had seen in the national press. It was some time before Alan found the explanation as to why No 13064 was not under its own steam. Weak bridges prevented the engine from passing in its entirety, so the side rods were removed and it was towed at a reduced speed. It was also something of a sensation when Compound 4-4-0 No 1093 from Nottingham arrived on a summer special in 1933. Even a Class 3 4-4-0 was a rare sight at Bath and he recorded only two in ten years — Nos 715 and 750.

Alan also spotted three extraordinary visitors to Bath: a Southern H16 4-6-2T No E516 running light, crept up the Midland line to Mangotsfield one day in 1927. His records for 1929 note that SR L12 4-4-0 No 416 appeared and one summer's day in 1930 0-4-2 No 624 could be found in a siding outside the S&D shed. In the early years of WW2 S11 and T9 4-4-0s became a common sight.

Alan's first real introduction to the Southern Railway came in September 1928 when he went on the first family holiday to Maidstone. The sight, sound and the smell of Victoria station presented yet another aspect of the railway world. His train drew out of Victoria about 7.00 p.m. and in the fading light he attempted to make a record of the locomotives, but the prefixes A, B and E threw him into such a state of confusion that he gave up. (He was unaware that they stood for Ashford, Brighton and Eastleigh Works). To make matters worse there came into view a tantalising forest of chimneys very much like the one he had passed a few hours earlier at Swindon. Later he understood that these probably belonged to the old Stirling Q and Q1 0-4-4Ts stored at Stewarts Lane, displaced by suburban electrification.

The memory of that journey to Maidstone is still clear in his mind. The first part was painfully slow, but then the Wainwright F1 4-4-0 went like Jehu's chariot and threw passengers against each other in the crowded compartment. He took to Maidstone immediately probably because he discovered something similar to Sydney Gardens at Bath, a park with trains running through. Brenchley Gardens overlooked the East station and the small locomotive depot which housed about eight engines, almost all of which were F1 4-4-0s.

Alan's first visit to Swindon Railway Works was in 1927 and was somewhat daunted by the massive gathering outside the entrance with the same object in mind. Eventually his group was assigned a guide whose attempts at explaining the various processes were completely lost in the deafening noise. He found the works disconcerting: he felt

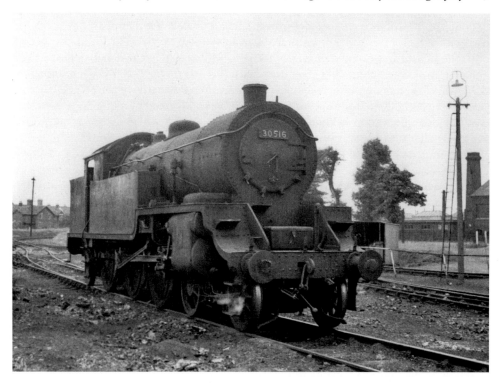

H16 class 4-6-2T No 30516 at Eastleigh, 4 July 1960.

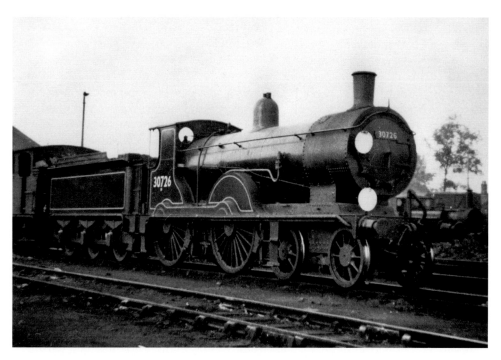

Ex-works LSWR T9 4-4-0 No 30726 at Eastleigh 14 June 1949. The tender has no BR emblem as it was repainted in the brief period between printing 'British Railways' and the application of the emblem.

uncomfortable about seeing a locomotive reduced to its constituent parts, particularly one with which he had been familiar when in working order. He still pictures two outstanding features of the visit: 4-4-0 No 4109 *Monarch* working hard on the test bed and getting nowhere; the other great memory is No 6001 *King Edward VII* not long off the production line on public view outside the works. Postcards of the engine were on sale and he bought one for 2*d*. Unfortunately it was consumed by a dog during tea that day. The dog in question belonged to a railway household, which no doubt accounted for its peculiar diet. He was promised a replacement, but it never materialised.

After the 1927 visit he did not set foot inside the works until March 1933 when a visit was organised for the upper forms of the school he attended. School parties on trains are always prone to mis-behaviour and this venture was no exception. What happened as the train puffed through Box Tunnel defies description, but Alan could not join in the fun as he was a prefect and had to sit with the headmaster and behave himself. What he saw on Swindon Dump is fascinating:

Cardiff Railway 0-6-2T Nos 153/8/62/3
 0-4-0T No 1339
Rhondda & Swansea Bay Railway 0-6-2T No 166
Barry Railway 0-6-2T Nos 199, 203/4/11/23/5/41/5/9/55
 0-6-0T Nos 712/8, 807
Taff Vale Railway 0-6-2T Nos 416, 502/52
 0-6-0 No 919
Cambrian Railways 0-6-0T No 821
 4-4-0 Nos 1043, 1110
Alexandra Docks & Railway 0-4-0T No 1340 (Which he photographed at Alders
Paper Mills, Tamworth 28 years later)
GWR 0-4-2T Nos 537, 846, 1160, 1425/8/31/83
 0-6-0T Nos 306/23, 645, 774/5, 947, 1021, 1151, 1556/72, 1774 and 1817.
 0-6-0 No 363.

Alan ventured into the realms of photography in 1931, his equipment consisting of an ancient Kodak box camera which boasted of only one view finder and that in the vertical position. He was much embarrassed when he saw his initial efforts. The Up Pines Express was an unidentifiable blur and his picture of 2-4-0 No 92 showed only the leading driving wheel, though 'LMS built Derby' could be read quite plainly on her splasher. He was proud of his picture of the wheel until those around expressed the opinion that it would have been more to the point if he had photographed the whole engine. Despite the deplorable state of his camera, coupled with his inexperience, he managed to secure a few presentable pictures and they bring on a bad attacks of nostalgia every time he sees them.

1932 was the year he discovered Bristol Barrow Road shed and Mangotsfield Junction. The GWR locomotive depots of St Philip's Marsh and Bath Road were well-known locations — but none in his group of enthusiasts had any idea where the LMS kept its engines. Then one day they hit on the notion of catching a train from Weston (Bath) station to Temple Meads — or rather two trains, for they had to change at Mangotsfield. Full fare cost 1*s* 4*d*. From Mangotsfield all the way down to St Philip's they had their heads out of the carriage windows and were surprised to find the object of their search very much nearer Temple Meads than they had imagined, enveloped in a cloud of smoke of unmistakeable Midland variety. At the rear of the depot was a gas holder of mammoth proportions visible over a large area, so it needed no exceptional

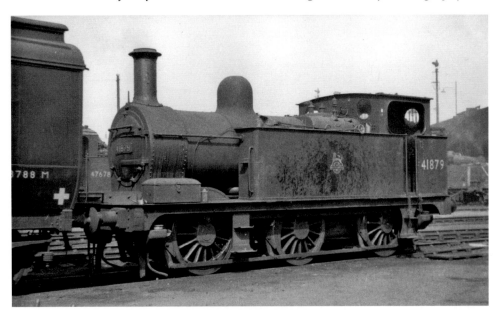

MR 1F 0-6-0T No 41879 at Bristol, Barrow Road, 21 April 1955.

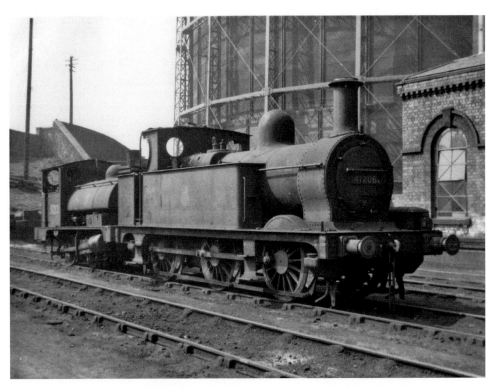

MR 1F 0-6-0T No 41706 and L&Y 0-4-0ST No 51212 at Barrow Road, 21 April; 1955.

Left: The interior of Barrow Road roundhouse 24 February 1934. Left is 4-4-0 Compound No 1078, with MR Class 3F 0-6-0 No 3180 to the right.

Below: LMS Class 4F 0-6-0 No 4276 taking water at Mangotsfield, 30 July 1936.

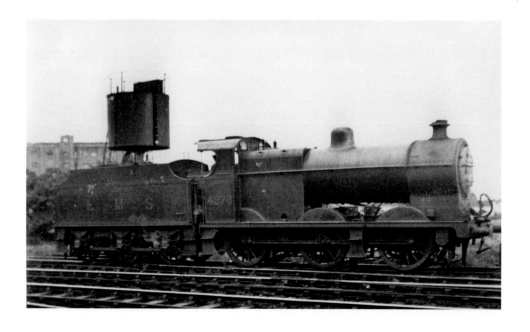

ingenuity on their part to locate the shed by homing in on that structure through a maze of unlovely side streets. So began a close acquaintance with a shed which was to last right through to the day of its closure.

The acquisition of a bicycle led to cycling trips to Mangotsfield. One consequence of the ventures into the Bristol area was a growing acquaintance with the Midland Class 3 and Compound 4-4-0s which at that time only appeared rarely at Bath. Those he recorded in the Bristol area 1932-3 were:

Class 3 Nos 710-3, 715-8, 745, 769-71 and 773-7 from Gloucester, Saltley and Derby.
Compound Nos 933-6, 1014, 1044-50, 1057-61 and 1098 from Derby; Nos 1000-2 from Gloucester; Nos 1005-8, 1016, 1032, 1056, 1063, 1075-9 from Sheffield; 1011/2, 1070/1, 1086/7 from Leeds, while 1023-31 were Bristol engines.

Like the Pines Express, the Devonian was a special point of interest and was worked almost invariably by a Sheffield Compound in reasonably good condition.

In August 1933 the family travelled by road to Sheerness. From there Alan could gaze straight across the Thames estuary to Southend on Sea. Oh how he yearned for a glimpse of the London, Tilbury & Southend Railway, so near and yet so far. He kept suggesting to his parents that a trip across the water in the PS *Medway Queen* would be delightful. To his surprise they yielded without much pressure and he was allowed to spend an hour or two in happy solitude on a convenient overbridge to the west of the station. The Stanier 2500 series of 2-6-4Ts had yet to be built so the 4-4-2Ts held sway and Alan found them to his liking. Some fifteen of them showed up — all Class 3 except for No 2103 a Class 2. This particular engine was the very one chosen for trials on the S&D towards the end of 1935 and was assigned to Templecombe for a time later she was tried on the Bath to Bristol service and produced mediocre performances. Apart from the 4-4-2Ts, the Class 3 0-6-2Ts were to be seen on freight workings and he was pleased to record the appearance on an Up passenger train, the first of the LMS-built class 4 0-6-0s, No 4027.

In October 1933 Alan's brother was intent on going to the Motor Show, so their mother took them both up to Town. Alan had extracted a promise from her that she would let him look in first at Euston and St Pancras, as yet unvisited. 14 October was a grey, cold day and the Doric arch at Euston struck him as somewhat ridiculous and incongruous edifice for a railway station. The station itself presented a dowdy appearance and was unexpectedly quiet. Having just left Paddington he registered a feeling of disappointment. Two Claughtons rested peacefully side by side at the buffer stops: No 5931 *Captain Fryatt* and the un-named No 5998. Prince of Wales 4-6-0 No 5613 *Sydney Smith* drew in empty coaching stock tender-first. Class 3F 0-6-0Ts Nos 16439 and 16550 were station pilots, while the first of the handsome Fowler 2-6-4Ts he saw were Nos 2378/80.

After this rather poor show at Euston, the consensus of opinion seemed to favour the abandonment of a visit to St Pancras, but nevertheless they decided to go. From the Underground they emerged into the station and immediately Alan was en rapport with the atmosphere of the place. It was undiluted Midland. He was impressed by the single span roof and loved to hear locomotive whistles reverberating under its expanse. A railway cathedral, bearing a saintly designation! His eye first caught sight of 0-4-4T No 1382 and then three others in quick succession — Nos 1371/4 and 1294. This was more like it! The real eye-popper was the station pilot, double-framed 0-4-4 well tank No 1211 beautifully turned out. He could not take his gaze off this wonderful old

SECR D class 4-4-0 No 1092 at Sheerness July 1934.

LTSR 4-4-2T No 2124 leaving Southend on Sea for Fenchurch Street, 2 August 1933.

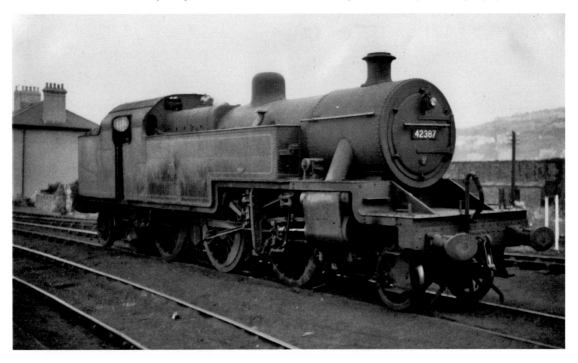

Fowler Class 4P 2-6-4T No 42387 at Swansea Victoria, 23 July 1953.

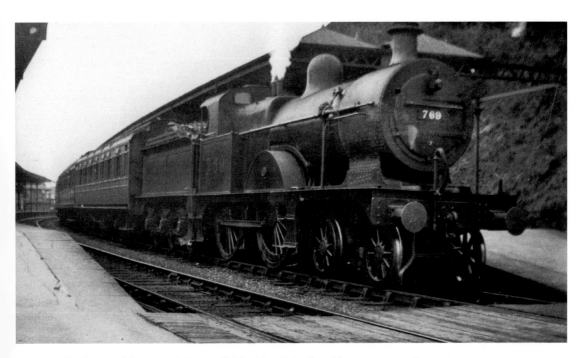

MR 3P 4-4-0 No 769 at Mangotsfield with a Bristol to Gloucester stopping train, 1933.

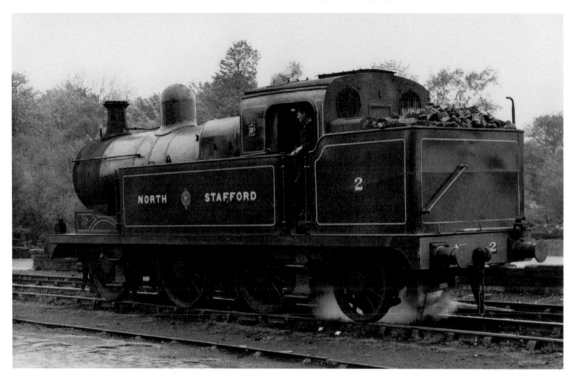

Ex-North Staffordshire Railway 0-6-2T No 2 at the National Coal Board's Walkden Colliery, 21 May 1963.

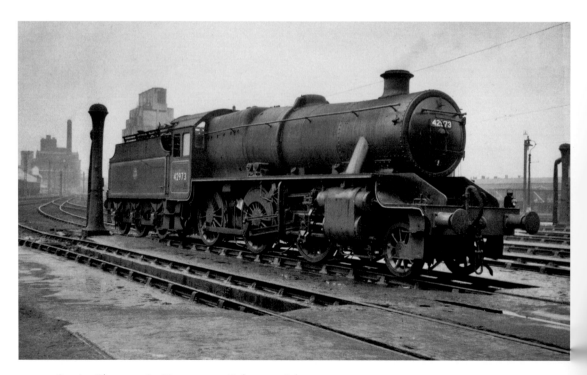

Stanier Class 5 2-6-0 No 42973 at Bolton, 20 July 1952.

lady who seemed to epitomise all that the Midland meant to him. In contrast, both in appearance and condition, were several Fowler condensing 2-6-2Ts fussing around with their five-figure numbers soon to be drastically reduced — 15500 became No 1.

Alan was delighted with his first view of a Baby Scot, as the Patriots were then called. He saw three: Nos 5905/73/87. At that time they were numbered amongst the Claughtons from which they were reputed to have been rebuilt, but nothing more unlike a Claughton was difficult for him to visualise. Midland Class 3 4-4-0s formed a prominent part of the scene and a bevy of Compounds completed the picture. Alan was not easily removed from this delectable pitch and as he reluctantly turned towards the station exit, newspaper vans were speeding in and out bearing posters with the ominous words 'Hitler Flouts the World'. It took another six years for the balloon to go up, but on 14 October 1933, standing at the portals of St Pancras, there was born in him the realisation that another war was a certainty.

The enthusiast of today cannot envisage what it was like to be a teenager in the nineteen-thirties living in a country with some 20,000 steam locomotives in service, more than a third of which were operating on the LMS. Despite a certain amount of standardisation, there was still a remarkable variety of engines and a fair sprinkling of ancient with the modern. Sometimes the monthly total of new engines going into traffic exceeded the number of those condemned. For example for the four weeks ending 20 April 1935:

> Built at Crewe: Class 5 4-6-0 Nos 5008/10-5.
> Built at Derby: Class 3 2-6-2T Nos 81-90.
> Built by contractors: Class 5XP Nos 5601-6; Class 5 4-6-0 Nos 5087-96.
> Engines condemned: Class 5 4-6-0 Nos 5920/32/90, 10430. Class 4 4-6-0 Nos 5770, 25676/8/82, 25707/10/1, 8800/8/28/9/48; Class 3 4-6-0 No 14693, 17911; Class 3 4-4-0 Nos 5235,14523 Class 1 4-2-2- No 14010 (to be preserved); Class 2 0-6-0 Nos 12027/42/50; Class 3 0-6-2T No 2267; Class 2 0-6-0T No 7526.

New locomotives totalled 31 and those withdrawn 27. The inclusion of the Caledonian Single in this list is interesting, as is the North Staffordshire Class 3 0-6-2T which he saw working at NCB Walkden in the nineteen-sixties.

On the LMS in the nineteen-thirties the most significant event was the appointment of William Stanier as CME and the consequent new look of his designs. For someone addicted o the Midland tradition, it was not easy to embrace such major changes as the taper boiler. The appearance of Class 5 2-6-0 No 13245, the first of the new Staniers, was nothing like as exciting as the final Fowler/Hughes No 13244, and gave little indication of the greatness to come in the shape of the Princess Royal; Jubilee and Black Five classes. The wind of change in locomotive development was certainly more marked on the LMS than any other system.

Chapter 3

He Makes his First Official Visit to a Locomotive Shed

In February 1934 Alan penned his first letter to D. C. Urie, Superintendent of Motive Power at Derby seeking a permit to enter the depot at Gloucester. Permission was granted for Sunday 4 March, for two persons (males only) and the return halves of two LMS tickets Bath to Gloucester were required to be presented. This was his first official visit to a locomotive shed. The permit in his pocket gave him, so he thought, an air of some importance, so on arrival it was with a feeling of being somewhat let down that he found there was no reception party — in fact he cannot recall having to show his permit to anyone. By the pathway to the shed several locomotives were stored, among them 2-4-os Nos 250 and 261 and o-6-oT No 1679. These three in particular seemed to have formed for some time a venture playground for local youngsters and he felt a sense of outrage when a group of them turned up for their daily exercise on those precious Midland veterans. The shed contained 52 engines, no less than 21 of which were Class 3 0-6-os. Among the more interesting specimens were three o-4-o Dock tanks, MR Nos 1537, LMS No 1540 and Lancashire & Yorkshire Railway No 11235. Five MR o-6-oTs were seen — Nos 1679, 1720, 1875/6/8; and solitary Jinty No 16548.

Alan and a friend had arrived at Gloucester at about 10.00 a.m. and with their departure set at about seven in the evening they had plenty of time on their hands. Once the first flush of excitement was over, they began to look around for something else to do and became aware of another centre of interest across the way — the Great Western shed. His colleague, who was more of a Western man, bemoaned the fact that they had no permit. Alan was not unduly worried until he glimpsed something through a hole in the fence, that something being 4-4-o No 3557 — which was withdrawn only two months later. This placed a different aspect on the situation.

No 3557 had enjoyed a fascinating history. Built as a broad gauge Convertible o-4-2ST in March 1889 and found unsteady, its pony truck was replaced by a bogie. Following the abolition of the broad gauge, No 3557 was converted to standard gauge in August 1892. The class still suffered from unsteadiness at the trailing end, so the outside frames were turned back to front in November 1899 when she became a 4-4-o tender engine.

Then came to Alan one of those rare occurrences. A young man who had been watching them as they searched for further holes in the fencing, offered to introduced them to the shed-master that afternoon and get them over the threshold. They ate their lunch on the footplate of stored 2P 4-4-o No 530 and then made the assignment with their new friend. Alan has no record of the actual number of locomotives there, but 55 of them were not already in his book, so it could well have been over 70. Apart

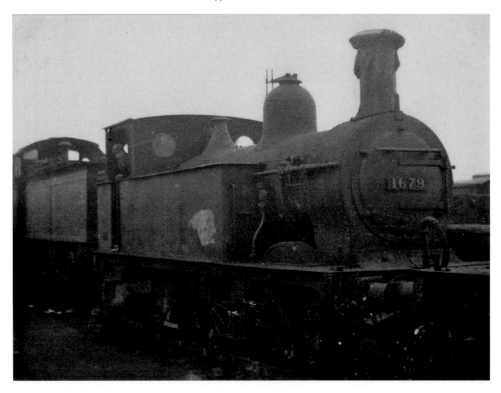

MR 1F 0-6-0T No 1679 stored at Gloucester, 4 March 1934.

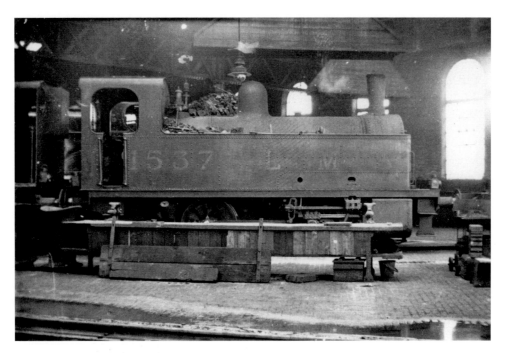

MR 0-4-0T No 1537 in Gloucester shed, 4 March 1934.

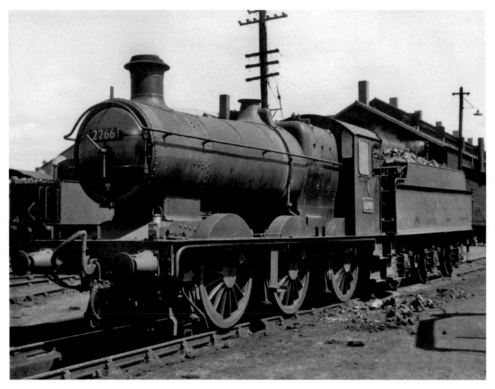

Collett 2251 class 0-6-0 No 2266 at Gloucester, 21 May 1958.

from No 3557, the most interesting items were ex-Midland & South Western Junction Railway 0-6-0s Nos 1006/9/10 and 4-4-0 No 1122.

There was a good variety of types present — several 2-4-0Ts and 0-4-2Ts, the latter being the new 48XX series, Dean and Collett 0-6-0s, an Aberdare 2-6-0 or two, ROD 2-8-0s, Dukes, Bulldogs, Saints and Stars, plus the ubiquitous Pannier tanks.

As Alan was now acquainted with the Chief Operating Manager's office at Derby, he thought he would do an Oliver Twist and ask for more. The booking hall at Bath LMS station offered a plentiful supply of leaflets advertising day, or half-day excursions, so he chose one scheduled to leave Bath for Nottingham at 9.30 a.m. on Sunday 3 June. The fare was 7s 6d. To penetrate Midland territory beyond Birmingham was an adventure and the mere thought of passing through the Mecca of Derby a thrill in itself.

The Chief Operating Manager obliged once again and it was with unbearable impatience that he waited for the day — and what a truly beautiful day it was when it arrived — unbroken sunshine from dawn to dusk, combined with the right sort of thermometer reading. His favourite locomotive, 2-4-0 No 157 drew him to Mangotsfield Junction where he joined the Nottingham train hauled by 2P No 522. The train was pleasantly empty so he was able to move from one side of the compartment to the other and look out of the windows. Bromsgrove and the Lickey Incline were the first points of real excitement, though disappointingly the Lickey banker, 0-10-0 No 2290 was nowhere to be seen. Four 0-6-0Ts were on banking duty: Nos 1933/4/5/7.

Unfortunately Bournville shed was missed as he was looking out on the wrong side, but as the train ran down into New Street he caught his first glimpse of one of the

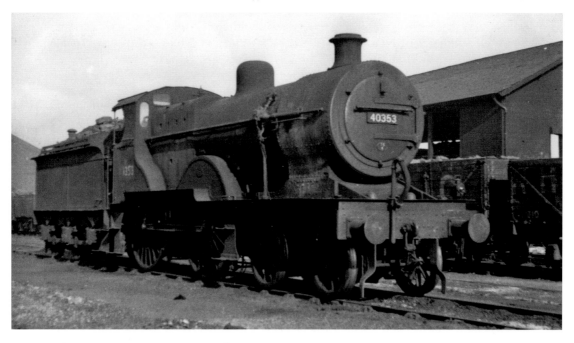

MR 2P 4-4-0 No 40353 at Nottingham, 17 May 1951.

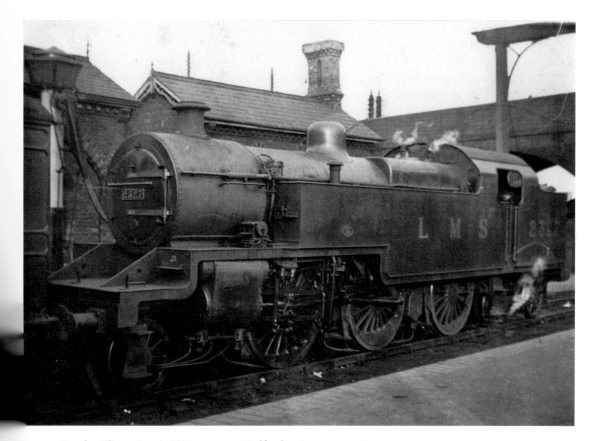

Fowler Class 4P 2-6-4T No 2327 at Bedford, 9 August 1936.

ungainly Midland 0-6-4Ts, No 2027 which was withdrawn two years later in March 1936. Drawing out of New Street, two LNWR Prince of Wales 4-6-0s were visible over on the North Western side. Burton on Trent seemed to have packed nearly all its engines inside the depot, but among the few standing outside was MR 0-4-0T No 1536. Derby put on a fine exhibition and the ex-works line-up shimmering under the summer sun was a sight to behold and it needed a good deal of self-discipline to hold on to his original purpose of going on to Nottingham. The engine at Derby which stood out in Alan's memory was Stanier 2-6-4T No 2508, brand new and formed the vision of things to come.

The environs of locomotive depots are not generally the most salubrious of places and Nottingham proved no exception. As he approached his destination he looked through another of those convenient holes in the fencing and when he espied MR 2-4-0 No 183 and double-framed 0-6-0 No 2603 he felt almost in heaven. Nottingham gave him his first experience of a multiple roundhouse and it was not surprising that he found himself going round in circles. Altogether he saw 107 engines comprising: 23 Class 2F and 3F 0-6-0s; 22 Class 4F 0-6-0s; 13 class 2P 4-4-0s; 9 Jinties; 8 Compound 4-4-0s; 6 LMS 0-8-0s; 5 MR 0-4-4Ts; 4 Class 3P 4-4-0-s; 4 2-6-0 Crabs; 4 MR 0-6-0Ts; 3 MR 0-6-4Ts; 3 MR 2-4-0s; 2 Fowler 2-6-4Ts and 1 LNWR 0-8-0.

He continued to Toton shed which presented an interesting contrast to what Nottingham had to offer. From a distance could be seen the massive hulks of the Beyer-Garratts and the lines of displaced smaller types mainly Class 2F 0-6-0s. There were 126 engines on shed comprising: 45 Class 2F and 3F 0-6-0s; 22 Class 4F 0-6-0s; 21 LMS 0-8-0s; 16 Garratts; 7 Jinties; 7 Glasgow & South Western Railway (GSWR) 0-6-2Ts; 4 LNWR 0-8-0s; 2 Fowler 2-6-4Ts; 1 MR 0-6-0T and one 0-6-0 diesel. The latter was MR 0-6-0T No 1831 reconstructed in 1932 as a diesel unit and as such, the direct forerunner of the standard LMS and BR diesel shunter. It received scant attention from Alan who found the most interesting engines to be the GSWR contingent namely Nos 16904/6/12/3/20/2/3.

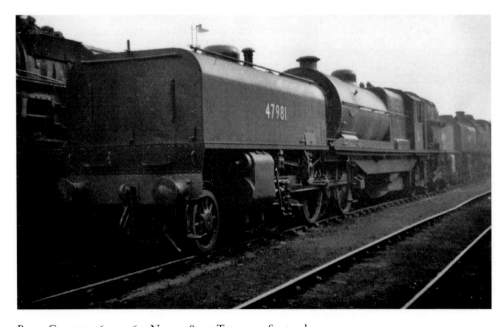

Beyer-Garratt 2-6-0+0-6-2 No 47981 at Toton, 11 September 1955.

Forgotten sandwiches were suddenly remembered and consumed as he stretched his tired legs on the platforms seat at Nottingham station and waited for Class 2P 4-4-0 No 522 to arrive with his train. Many times on reflection he wished he had rounded off the day at Victoria station, but interest in the LNER had not then come to birth. It was a fitting finale to the day when on the way home he spied LNWR 4-4-0 No 5320 *George the Fifth* in the dark caverns of Birmingham New Street. He slept most of the way to Mangotsfield from where Class 1P 0-4-4T No 1309 carried him to his local station, Weston (Bath) where he arrived at about 2 a.m. Off to school six hours later was not a welcome exercise!

At the beginning of 1934, Alan started to keep a day-to-day diary of locomotive movements in the Bath area. Some quotes from it are:

Monday 15 January: the local evening paper contained an article about the Dabeg warm water feed apparatus affixed to S&D 4-4-0 No 633.

Saturday 12 May: Bath shunter MR 0-6-0T No 1870 has suffered damage to front buffer beam; now shunting bunker-first.

Friday 18 May, the following have been assigned to the S&D for holiday traffic: Class 2P 4-4-0 Nos 508/24; Class 4 0-6-0 Nos 3840, 4166/7; 4523/5.

Saturday 19 May: several pigeon specials today with the unusual sight of three arriving behind Class 3 0-6-0s. Probable first appearance of a Stanier Mogul at Bristol, No 13262 from Leeds.

Whit Sunday 20 May, engines in Bath shed: 2-4-0 Nos 92, 157, Class 2P 4-4-0 Nos 321/4 508/24/31, 629/30/5, 0-4-4T Nos 1309/34, 0-6-0T No 1870, Class 2 0-6-0 No 3078, Class 3 0-6-0 Nos 3198, 3211, 3792, Class 4 0-6-0 Nos 3840, 3924/6, 4106/66, 4278, 4523/57/9/61, 0-6-0T Nos 7153, 7316, 2-8-0 Nos 13800/3/6/7/9/10. Total 36.

Friday 25 May: two Newton Heath Cl 4 0-6-0 Nos 4212/4 arrive with pigeon specials, while No 4335 from Sheffield comes in on a local freight and is immediately pressed into service on the S&D.

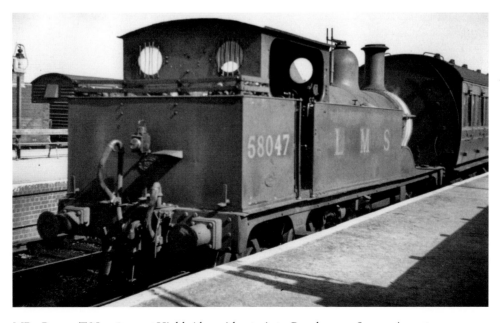

MR 1P 0-4-4T No 58047 at Highbridge with a train to Burnham on Sea, 22 August 1951.

Saturday 26 May: More pigeon specials with Class 4 0-6-0s No 4346 from Edge Hill and No 4444 from Longsight among the best surprises. 97 locomotives seen this day in Bath and Bristol.

Saturday 14 July: Class 2 4-4-0 No 372 of Hasland shed brought in a new titled train The Bournemouth Rapid.

Saturday 21 July: Class 2 4-4-0 No 443 from Sheffield arrived on The Bournemouth Rapid, was quickly turned and used on the Up Pines Express leaving just an hour later. Nos 387 (also from Sheffield) and No 372 double-headed the return Rapid.

Monday 23 July: Bath water softening plant is now taking shape. Two old LNWR tenders were shunted into position and connected to the softening tower. Class 4 0-6-0 No 4424 appeared with the red tender of Crab No 13061. The number had been crudely painted over, but was still visible.

Saturday 4 August: Class 4 0-6-0 No 4435 also appeared with a red Crab tender. No 4417 and No 4045 have swapped tenders, so that 4417 has LMS on cab and tender, while 4045 displays two numbers.

Saturday 11 August: a notable day — over 100 locomotives observed in Bath and Bristol of which 42 were class 2 4-4-0s. Class 3 4-4-0 No 770 at Bath — a rare occurrence.

Saturday 18 August: No 2767 appeared the first sighting of a Crab since No 13064 (2764) was used on trials over the S&D in 1928.

In 1935 Alan noted that Patriots and the new Jubilee class engines were becoming a common sight in Bristol, both on the 10.35 a.m. to Sheffield and on the Up Devonian. He first saw a Jubilee (No 5622) on 19 January. Nos 5594, 5623/56/8/62/3/4 all appeared within the following month and the Patriots took their leave. Occasionally a Compound still headed the Devonian. Nos 1088 and 1117 appeared with tiresome regularity, sometimes piloted by a 2P 4-4-0, but this duty was now virtually at an end for four-coupled locomotives.

Chapter 4

Alan Leaves School

From October 1934 Alan obtained a post with a music firm in Bath which on Mondays to Fridays took him to its Bristol branch. Naturally he travelled to Temple Meads daily by rail and was able to see the Up Devonian; on 28 December Patriot No 5511 bearing a Bristol shed code provided a memorable surprise.

It was with mixed feelings that Bath railway enthusiasts received the news that the old manual turntable was to be replaced. It was prone to breaking down at the most awkward moments and this provided extra entertainment for the enthusiasts as well as increasing their knowledge of railwaymen's vocabulary. At times there could be a queue of as many as eight locomotives waiting their turn and when things became really tight on a summer Saturday, some were even sent to Mangotsfield to turn on the triangle.

The GWR as far as Alan was concerned was mostly heard but not seen at this period. When things eased off a little on the LMS scene he would only need to go 200-300 yards up the road to a convenient overbridge to grace the other line with his presence. A new Castle or Hall would create a flicker of interest, but he would have preferred to see a 2-8-0T or a 0-6-2T, for both these classes were rare at Bath. The Down Swindon running-in turn which left Bath at about 8.50 a.m. was not only used by new engines, but by others which had gone through the works. His way to school took him over the Midland line at the Weston level crossing and under the GWR line on the other side of the Avon. How convenient! If word got round that something out of the ordinary was on the running-in turn, he would risk a late arrival at school to see it. He well remembers how one of the big 2-8-0s, No 4705, cost him a black mark or two.

1935 was to be a year of expansion, for now Alan was earning the princely sum of ten shillings a week and could afford to go places. A modest start was made with a visit to Burton on Trent and Derby on Sunday 26 May — yet another day of unbroken sunshine. 0-4-4T No 1408 carried him to Mangotsfield and 4-4-0 Compound No 1024 took him onwards. This time Big Bertha No 2290 was waiting for him and banked to the top of the Lickey. He enjoyed a feeling that was hard to analyse when he actually saw something for the first time in the flesh, which he had been acquainted with for years only in photographic form. Fourteen years later, LNER Beyer-Garratt No 69999 did not register with him anything like this excitement.

At New Street LTSR 4-4-2T No 2098 was on pilot duty. Along with several others she had been displaced from the Tilbury line by the advent of the new 3-cylinder 2-6-4Ts, the Midlands having become a reception area for these refugees. As he drew near to Burton on Trent he became aware of the fact that something very odd was standing tender-first in the approach road to the shed — J3 0-6-0 No 4116. Apart from the Great Central locomotive he saw at Marylebone back in 1925, this was his first confrontation

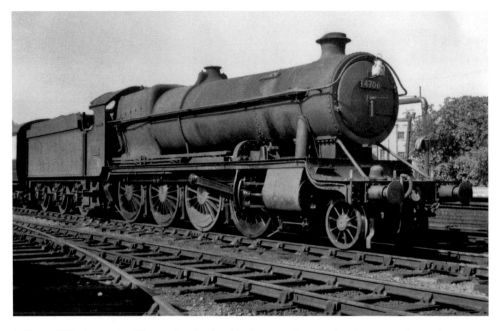

GWR 47XX class 2-8-0 No 4706 at Bath with the morning running-in turn, 7 September 1953.

with a specimen from the unknown territory of the LNER. He found 64 engines at the Midland shed, one being ex-S&D 4-4-0 No 321. Luckily Alan discovered that there were two sheds at Burton and the old LNWR depot, though much smaller, contained a rare collection. He saw no less than eight Cauliflowers, most, if not all, stored out of use. The remainder of the 32 engines were: 7 MR Class 2F and 3F 0-6-0s, 6 LNWR 0-8-0s, 3 Class 4 0-6-0s, 2 LNWR 19 inch 4-6-0s, 2 North Staffordshire 0-6-0s Nos 8673/5, 1 LNWR 0-6-2T, LNWR 0-4-2T No 7858, 1 MR 0-6-0T and 1 MR 0-4-0T.

Having been pleasantly surprised at what Burton had to offer, he went on his way to Derby expecting even greater things, and was not disappointed. He presented his credentials at the little office at the bottom of that long footbridge which spanned the tracks and led to the shed yards and works. This time he was given a guide. Altogether 205 locomotives were on site including a three year old Stanier 0-4-4T and a Glasgow & South Western Railway 0-6-2T. Preserved Midland Single No 118 was in the paint shop together with newly constructed 2-6-2Ts Nos 98/9. Various classes of 0-6-0 dominated the scene with well over a third of the total on that occasion. As the sun began to sink towards the western horizon, he remembers how it illuminated a line of newly painted engines ex-works and he stopped on the footbridge to admire this fantastic sight. Fires were being started and a haze forming over the whole scene. He felt supremely happy and privileged to be at the heart of the Midland Railway.

Evening trips from Bath (Queen Square) to Birmingham were advertised, leaving at about 4.30 p.m. They were primarily designed for theatre-goers, but at only 2s 9d were excellent value for the railway enthusiast who preferred New Street as his stage. Unfortunately Alan was never free to use such a bargain, but on Sunday 11 August he travelled northwards to seek out Saltley's stock and go on to discover what Aston and Monument Lane sheds had to offer. It was yet another glorious day, although perhaps uncomfortably warm for treading the dust and ashes of engine sheds. On the Up journey he observed S&D 2-8-0 No 13800 rather off her beaten tracks at Gloucester, while outside Bournville shed were

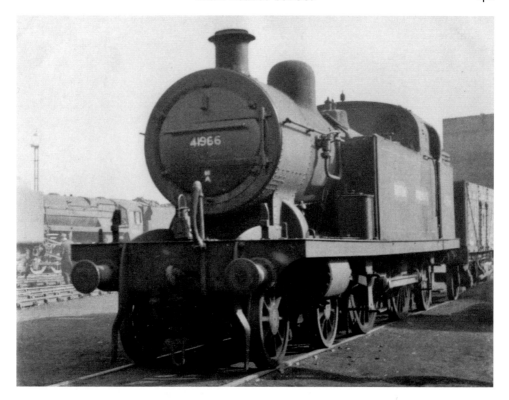

LTSR 4-4-2T No 41966 at Toton 11 September 1955. It was originally named *Thundersley*. No 41966 was the last of the class in service in unaltered condition.

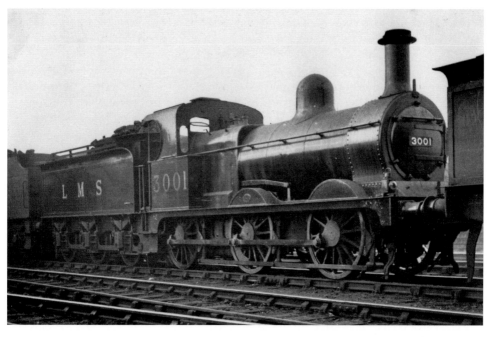

MR 2F 0-6-0 No 3001 ex-works at Derby 8 August 1937. It has the sans-serif style of number on the smoke box door, but the other numbers and letters have serifs.

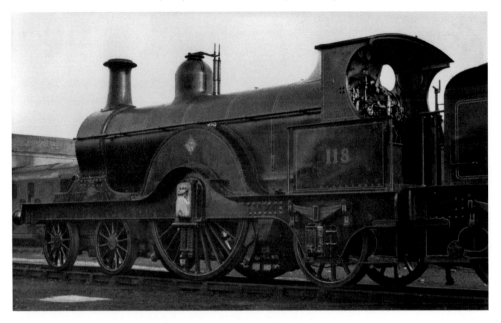

Preserved MR 4-2-2 No 118 at Leicester, 26 February 1968.

three MR 0-6-4Ts (No 2031/6/7) lying idle with new 2-6-2T No 91 nearby as a reminder of their impending demise. No 114 of the same class was the New Street pilot.

131 engines were seen at Saltley, mostly MR/LMS types with 7 LNWR 0-8-0s, and No 5984, the last of the original Claughtons. One LTSR 4-4-2T was seen, but Stanier engines were few.

The 60 engines seen at Aston were of 20 different classes, of which 11 were LNWR. Monument Lane shed contained only 35 engines, but no less than 16 different classes were represented there — an amazing variety for such a small depot. There were four 4-6-2Ts (Nos 6950/6/7/94) and these large tanks were disappearing quickly.

School holidays were now a thing of the past for Alan, but he was granted one week's leave — a generous gesture he was given to understand — from 24 -31 August 1935, without pay. On arrival at Paddington he went straight to Euston with the hope of getting his first view of a Royal Scot, but in the event had to wait until the following day for this. However Pacific No 6205 *Princess Victoria* in exhibition condition, provided an acceptable substitute. Patriots, Jubilees and Black Fives were most in evidence. A quick dash into St Pancras was rewarded with the sight of the MR 0-4-4 well tank No 1219 on station pilot duty. The scene here was virtually unchanged from that of his first visit in October 1933, but the Fowler Patriots then present had been replaced by new Stanier Jubilees, whilst the Fowler 2-6-2Ts had shed their five-figure numbers.

The following day he went to Cricklewood and out of the 66 engines there, no less than 38 were 0-6-0Ts. 17 were MR 2F and 3F 0-6-0s whilst 5 were Garratts. A visit later in the week produced no surprises, except for a Dumfries-based Compound 4-4-0 and a couple of SR C class 0-6-0s. Kentish Town had a little more variety among its 78 residents. This depot had nearly all of the Fowler condensing 2-6-2Ts (Nos 21-40) of which only 2 were actually present, the rest being out on duty. Then it was back to Euston and at 8.30 p.m., in the cool of the evening stood his first Royal Scot, No 6150 *The Life Guardsman*. Yet again he relished a moment when a pictorial acquaintance of some seven years or so was transformed into reality. Although the post WW2 rebuilds of the Scots were reckoned to

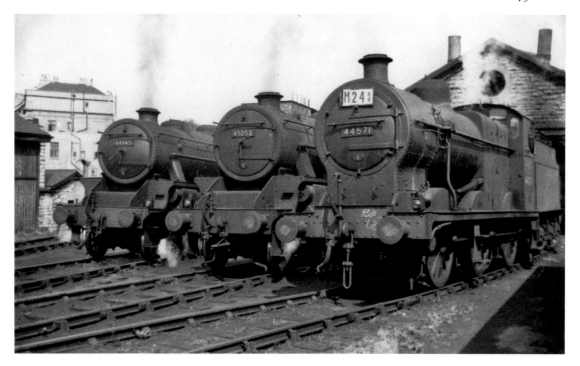

Bath 23 July 1955: LMS 4F 0-6-0 No 44571; Class 5 4-6-0 No 45252 and No 44945.

Jubilee 4-6-0 No 5620 *North Borneo* leaving Tamworth, 27 August 1938.

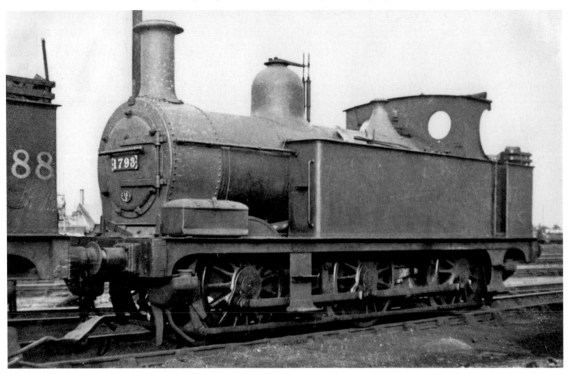

MR 1F 0-6-0T No 1793 at Bedford, 9 August 1936.

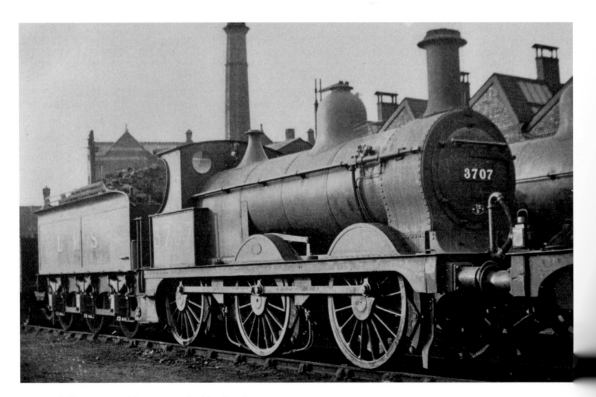

MR 2F 0-6-0 No 3707 at Bedford, 9 August 1936.

make them very handsome machines, Alan held a great liking for them in original form with their massive boiler barrel which seemed virtually to swallow chimney and dome.

On Monday 26 August he travelled to Bedford behind Compound No 1007. His main motive in going there was simply to see some more members of his favourite class the Midland Jumbo. Two were in the shed, Nos 20188 and 20267, in beautiful condition. No 20115 was out working, but turned up later at the station. Only 17 engines were on shed, but every one was pure Midland. There was a fair frequency of traffic through Bedford, some 30 movements being recorded within a couple of hours, and it was there that a new Stanier type appeared on the horizon in the form of 8F 2-8-0 No 8001, then assigned to Wellingborough.

Alan recorded some 500 LMS locomotives in the London area during his week's stay there, but ex-LNWR representation was painfully small — just 43 of that total. The 4-4-0s topped the list with 10 Precursors and 3 George the Fifths, while 9 Prince of Wales 4-6-0s found their way into Euston during the week. Most pleasing of all was the appearance of two of the few remaining Claughtons: No 5999 *Vindictive* with two more years' service ahead and No 6017 *Breadalbane* which lasted until 1940.

The SR shed at Reading, easily visible from passing GWR trains, produced an interesting variety: M7 0-4-4T No 324, H16 4-6-2T Nos 516/8, T6 4-4-0 No 685, R1 0-6-0 Nos 1634/7, R1 0-4-4T No 1699, C2 0-6-0 Nos 2435 and 2533.

In May 1935 Alan became Member No 795 of the Railway Correspondence & Travel Society and that autumn joined a trip to Rugby, Bletchley and Northampton sheds. 20 October was a magnificent day and with it came an LNWR jamboree. Out of the 105 engines on shed at Rugby, no fewer than 84 were of LNWR origin. Bletchley held 52 engines (40 LNWR) and Northampton 48 (36 LNWR), so out of a total of 205 locomotives, only 45 were not of LNWR origin. How those Precursor names linger in his memory: *Senator, Vesuvius, Velocipede, Bucephalus, Greyhound, Hydra, Etna, Snake, Emerald, Amphion, Erebus* and *Perseus*. The images such words generated,

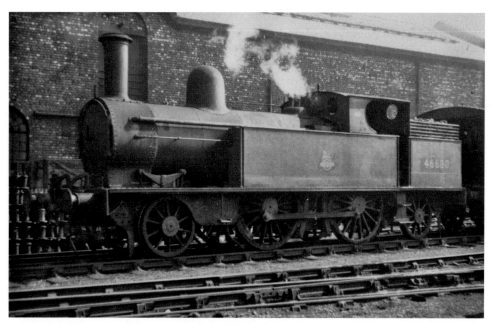

LNWR 2-4-2T No 46680 at Crewe Works, 17 May 1951.

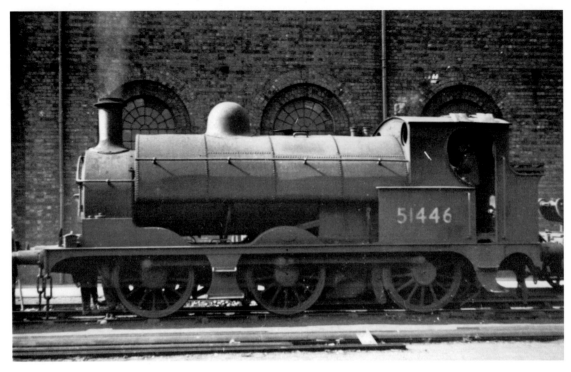

L&Y 0-6-0ST No 51446 at Crewe Works, 17 May 1951.

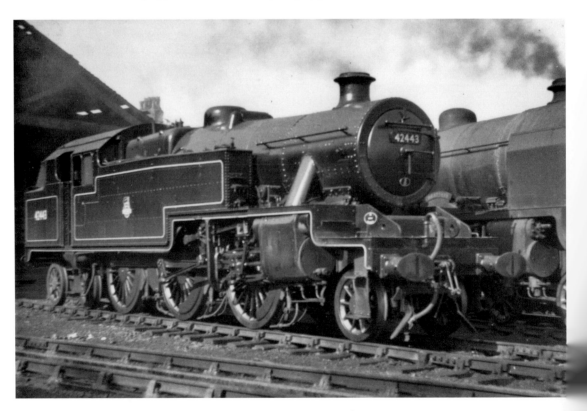

Ex-works Stanier Class 4P 2-6-4T No 42443 at Crewe North, 17 May 1951.

fitted in so well with the whole essence of the steam locomotive, for after all, Castle, Court, Hall or Manor is, when you come to think of it, peculiar nomenclature for a locomotive as such objects are far too static and impersonal.

On 15 December 1935 he joined a half-day excursion to Liverpool, booking as far as Runcorn. Leeds Compound No 1117 was the train engine from Bristol. Passing Bescot there was a veritable mass of engines in the shed yard, mostly LNWR 0-8-0s. He saw Bushbury and Stafford sheds for the first time, two Prince of Wales and 4-6-2T No 6992 standing outside the depot. Crewe was reached behind schedule and the daylight beginning to fade. In Crewe North shed he found 116 engines, over a third of which were LMS 4-6-0s, though the LNWR contingent was surprisingly good amounting to 42. Two ex-North Staffordshire engines were there while the real gem was MR double-framed 2-4-0 No 20022.

The South shed contained 77 engines representing 22 classes, but with a single representative in 8 of them. Here Alan made his first acquaintance with the Stanier Mogul. Thirty years later, at the end of the steam era, he returned to the shed on a weekday and found 94 engines there, mainly Black Fives, 8F 2-8-0s, 9F 2-10-0s and Britannias. This was his last sight of a large concentration of steam on shed and he endeavoured not to regard the frightful condition of everything, but rather to capture the atmosphere of what was once a common sight in Britain.

Back in 1935 Alan arrived at Warrington with the light almost gone and walked along the track to the shed with two Royal Scots, the *Seaforth Highlander* and *Black Watch* passing uncomfortably close. The shed contained 42 engines, its most outstanding feature being the presence of no less than 7 Prince of Wales class, 3 4-6-2Ts, an 0-8-4T and 0-6-0ST *Earlestown* from Wolverton Carriage Works.

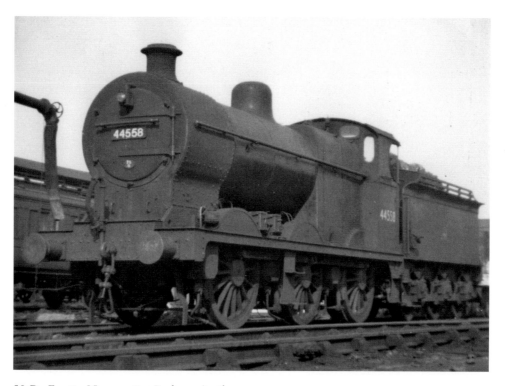

S&D 4F 0-6-0 No 44558 at Bath, 22 April 1951.

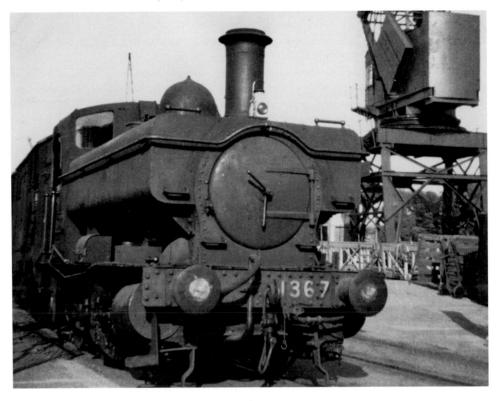

1366 class 0-6-0PT No 1367 at Weymouth Harbour, 25 June 1949.

LTSR 4-4-2T No 2103 at Bath, 16 July 1936.

Widnes had 24 engines including a couple of L&Y 0-6-0STs Nos 11428 and 11528 of a class that was new to him. Alan will always remember Widnes as the shed he entered back to front: in through the coaling plant and out through the foreman's office — much to his surprise.

Chester, the last port of call for the day, was done by gaslight. 33 LNWR locomotives including 9 George the Fifth 4-4-0s, 6 Prince of Wales and 2 19 inch 4-6-0s, out of a total of 49. The sight of a GWR Hall standing in Chester station on his return seemed an completely incongruous ending to all that had gone before.

Regarding events in the Bath area, Monday 28 January 1935 saw the arrival in Bath of MR 2-4-0 No 254 with the Engineer's saloon which stayed overnight. No 254 was stabled in the main shed sidings and there was enough light from a nearby lamp to see a strange object fixed to the smoke box door — a shed plate bearing the new code 3C, Walsall. Just a month later Alan noted an epidemic of 22C, which was Bath's new and very first code. The daily Saltley goods was now almost exclusively in the hands of Class 4 0-6-0s, though the engines came from a wide variety of depots such as Leeds, Canklow, Hasland, Peterborough, Leicester, Kettering and Bescot.

The local pick-up goods could produce a surprise or two, such as when double-framed 0-6-0 No 22852 appeared from Saltley spending a week in the area. On Thursday 7 March Alan noted that Bath's new turntable was brought into use and as a consequence he noted a week later than the S&D 2-8-0s were now arriving facing the city as they could now be turned.

As the summer of 1935 approached Alan was faced with a problem. Now in employment, no longer were his Saturdays free to exercise a day-long lineside vigil, so he had to devise a new plan of campaign. Fortunately on his way to work in the city, (he was not required to travel to Bristol on Saturdays), he could make a small diversion and pass by the sheds and so look on at the proceedings between 8.00 and 8.30 a.m.; he could pay another visit during the lunch break and a final call from 7.00pm to dusk and sometimes beyond.

Most of Britain had a holiday on 6 May to celebrate King George V's Silver Jubilee, so Alan took advantage of his season ticket to have a good look around Barrow Road. Two new Black Fives were there: Nos 5031/2.

On Saturday 13 July Alan was granted a half day's leave to join his church choir outing to Weymouth via the S&D. S&D 4F 0-6-0 No 4561 drew them there and back. The route led through Hamworthy Junction and by its little shed containing a fascinating collection of LSWR items: T1 0-4-4T Nos 7, 73 and 364, B4 0-4-0T No 94, A12 0-4-2 No 611 and X6 4-4-0 No 660. Three King Arthurs and a Lord Nelson, all in lovely condition were on Weymouth shed, while several O2 0-4-4Ts were out and about. The GWR provided such items as 0-4-2Ts Nos 528 and 1433, No 2705 *Saint Sebastian,* Bulldog No 3421 and 0-6-0PT No 1367 working the Quay Tramway.

On 1 October 1935 Alan heard a new sound passing his home and from the rhythm of the rail beats surmised it to be a 4-4-2T. He made haste to Bath shed and there in the gaslight saw LTSR No 2103. There was a good deal of ribald comment going on amongst the shed staff concerning this latest arrival, loud and clear and not very complimentary. Their fears about the capability of this engine to contribute anything useful to local operations were soon to be realised.

On Wednesday 9 October Alan noted that No 2103 was assigned to the 5.00 p.m. Bath-Templecombe run, that she failed and that MR 0-4-4T No 1404 had to go to the rescue. On Friday 18 she was back again on this turn and fitted with a Templecombe shed plate 22D, but a week later Alan noted: '2103 failed again. Now dumped in shed sidings'. The final mention comes on 15 November '2103 now demoted to the Bath-Bristol run'.

Chapter 5

1936

2 February 1936 Alan purchased at the cost of 9s 0d, a half-day return from Weston (Bath) to Runcorn. The planned programme was shed visits to Crewe North and South, Wigan (Springs Branch and Central), Sutton Oak and Edge Hill — a fair assignment for a half-day!

Compound No 1023 was his motive power from Bristol. New 2-6-2T No 116 was the station pilot at New Street and Bescot shed was full to overflowing with LNWR 0-8-0s, while Stafford once again delighted him with a Prince of Wales, 2 19 inch 4-6-0s and a Precursor 4-4-0. 94 engines were on Crewe North shed with the mixture much the same as it had been the previous December. Claughton, No 6023 *Sir Charles Cust* was a joy to behold, though when he saw the name he wondered what had upset the fellow. Alan saw all the Claughtons in his various excursions and not one of them was ever in poor external condition.

Crewe South contained 72 locomotives including yet another resplendent Claughton No 5908, even though she was destined for the scrap road. North Staffordshire representation was down to two engines, 0-6-0 No 8677 and 0-6-2T No 2241. The sight of Garratt No 4990 came as something of a surprise and formed a stark contrast with Sentinel 0-4-0T No 7192 standing nearby. The diesel invasion had begun in the shape of 0-6-0 Nos 7070/1/2 but at the time Alan saw no significance in this.

In the gathering gloom of this February day he made his way to Wigan. Springs Branch, the 'A' shed of Area 10, was to prove a place of importance. 82 engines were waiting for him there and out of that total, only 7 were post-grouping standard types, namely 4 Black Fives, 2 Jinties and a Crab. The rest of the total consisted of 29 LNWR 0-8-0s, 4 0-8-2Ts, 8 Prince of Wales 4-6-0s, 4 19 inch of the same wheel arrangement, 1 George the Fifth 4-4-0, 5 Cauliflower 0-6-0s, 4 0-6-2Ts and 3 0-6-0STs. The L&Y was represented by 12 0-6-0s, 4 2-4-2Ts and 1 0-8-0.

His next port of call, Wigan Central, the 'D' shed of Area 23, but certainly not one to be despised because of its lower rating, though its location and general appearance left much to be desired. This was Alan's first experience of L&Y territory. 53 locomotives were on site. The quality of the gas lighting was appalling and made identification difficult. Of L&Y origin 22 0-6-0s were present, 11 2-4-2Ts, 5 0-6-0STs, 4 0-8-0s, 1 LNWR 0-8-0, 1 Cauliflower, 1 Prince, 1 MR 3F 0-6-0, 3 Compound 4-4-0s, 2 Standard 2P 4-4-0s, 1 4F 0-6-0 and 1 2-6-4T.

Sutton Oak was at the bottom of the Area 10 list but nevertheless housed no less than 40 engines. Apart from 4 Jinties and 2 standard 4F 0-6-0s all the other 13 classes were of LNWR or L&Y origin.

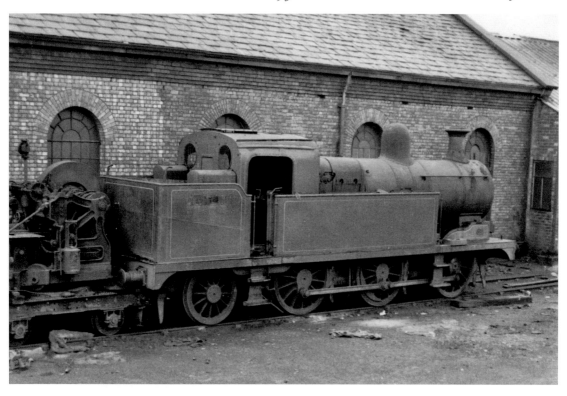

North Staffordshire Railway 0-6-2T (ex-LMS No 2264) at the NCB Walkden Colliery 21 May 1963.

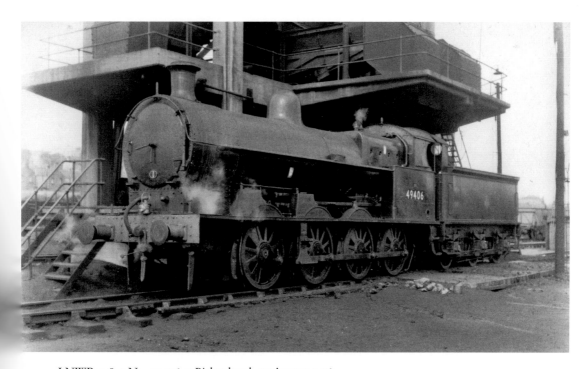

LNWR 0-8-0 No 49406 at Birkenhead, 17 August 1960.

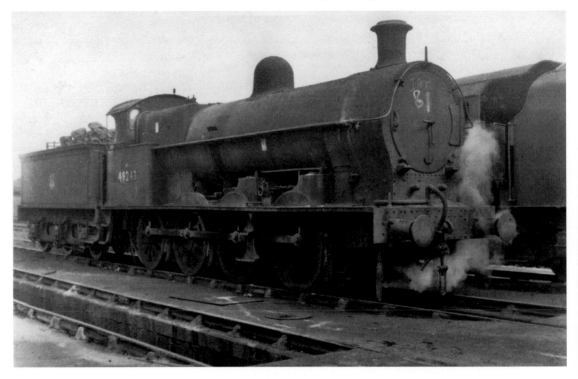

LNWR 0-8-0 No 49243 at Edge Hill, 17 August 1960.

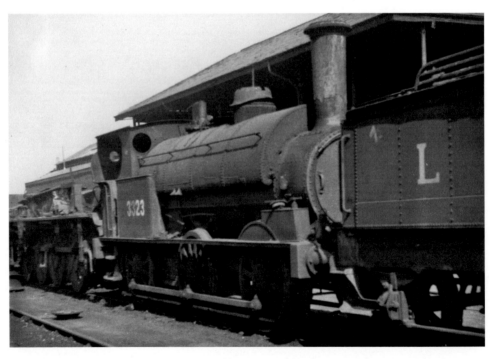

LNWR Special Tank No 3323 at Crewe Works 17 May 1951. Behind it is the frame of an Austerity 2-8-0.

Alan was now beginning to get rather short of time and only just caught his connection at St Helen's Junction. He was told that whatever happened, Edge Hill must be covered and that a real treat lay in store for anyone on a first visit. That prediction was fully justified. He felt there was certainly something different about the place as soon as he set foot inside. There was no flickering gaslight here, but modern electric lighting, and the shed bright and very tidy. 101 engines were present and altogether 63 were LNWR and only one L&Y example was present. Edge Hill was indeed a grand finale to a remarkable day's outing. With virtually only minutes to spare, he joined the train at Lime Street for a 9.00 p.m. departure. As it drew out of the station and just before Alan sank into deep slumber, Prince of Wales No 25792 of Huddersfield ran into an adjoining platform. Just the thing to dream about!

In most of the popular railway literature of the nineteen-twenties, two classes of ex-L&Y locomotives were depicted as the very essence of advanced modern construction, namely a Hughes 4-6-0, (usually No 10456 was depicted), and its Baltic tank version. Although 41 were still in service at the beginning of 1936, it was clear to Alan that their days were numbered and he felt he could not let them disappear without catching sight and sound of at least some of them. When excursions to Blackpool were advertised from Bath he determined to use one of them to fulfil this desire, so on 20 June he joined the well-packed train.

It was a lovely day for a lovely ride: no winter darkness over Crewe, Warrington and Wigan this time! Passing Walsall shed he spied the familiar figure of 2-4-0 No 157 — a favourite of his from Bath. Outside Bushbury shed stood No 6100 *Royal Scot* which had until that time eluded him in his travels, while the last of her class, No 6170 *British Legion* rebuilt from the experimental No 6399 *Fury,* was the showpiece among the engines grouped around the approach roads to Crewe South.

The run from Crewe through Warrington, Wigan and Preston presented a variety of locomotives difficult for the latter-day observer living in a world of a few standard

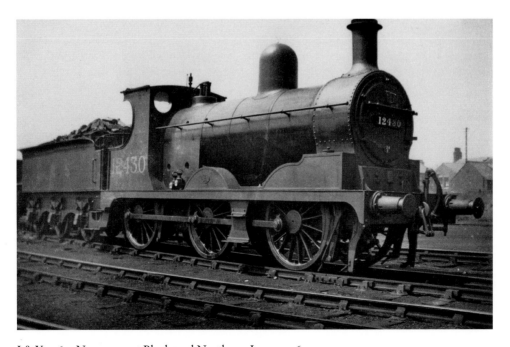

L&Y 0-6-0 No 12430 at Blackpool North, 20 June 1936.

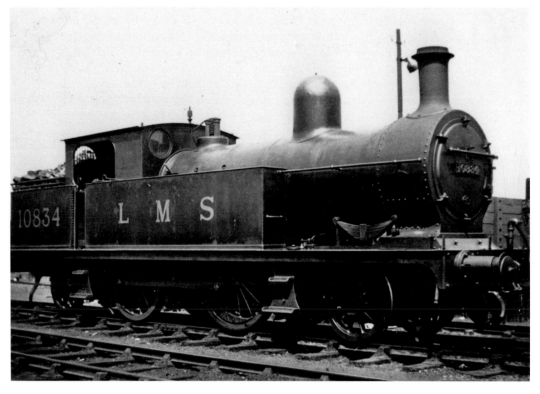

L&Y 2-4-2T No 10834 at Blackpool Central, 20 June 1936.

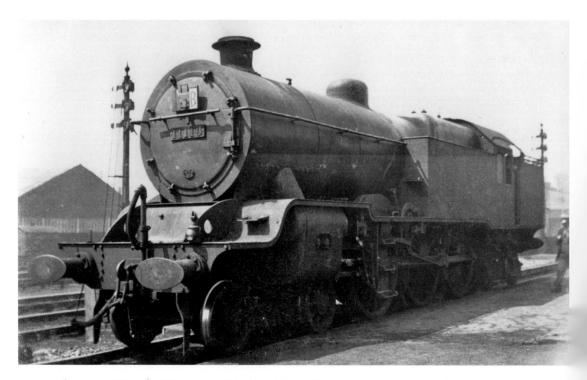

The vast L&Y 4-6-4T No 1113 at Blackpool Central, 20 June 1936.

types to imagine — some 28 different classes in total. Alan was surprised and somewhat disappointed to see nothing of Hughes' big engines between Preston and Blackpool and it was not until his train was entering North station that he saw outside the shed a red beauty — No 10455. Without a doubt it was a handsome machine, but sadly the writing was on the wall. Ten survived into the nineteen-forties, saved by the demands of WW2, whilst No 10442 soldiered on until September 1950.

Blackpool Central offered 8 of the class that day and here he had his first sight of a Baltic tank — No 11113, a rather work-worn specimen from Agecroft shed. There was a veritable host of L&Y 2-4-2Ts and 0-6-0s, while among the Standard types, Compound and Crabs figured prominently. After consuming part of his lunch in the environs of Central shed, he decided to retrace his steps to Preston and was delighted to find that the engine hauling his train was Hughes' 4-6-0 No 10429. He took the opportunity to quiz the footplate crew on the performance of this class, but they in no ways shared his enthusiasm. 'One run to Preston and back and the damned thing shakes itself to pieces' was the comment of the fireman. Alan rode in the compartment next to the tender. It was a rough ride and no mistake. He never had the opportunity to ride behind a Baltic tank, but gathered that their reputation was of a no higher degree and certainly the whole class had been withdrawn by January 1942.

The buildings of Preston shed seemed a shambles to Alan and he wondered how they coped. Royal Scots, Jubilees and Black Fives formed an odd conglomerate with a fair number of L&Y 0-6-0, LNWR 0-8-0s and a sprinkling of Jinties and Dock Tanks. The intensity of traffic through Preston was quite phenomenal. Before he left the town he saw two of the huge 4-6-4Ts come into view — No 11116 and No 11118, both working from Bolton. 4-6-0 No 10412 drew his train back to Blackpool and he considered his day's project had been fulfilled satisfactorily. The journey homewards from Blackpool North began at 1.30 a.m. or thereabouts. He awoke south of Cheltenham in time to see Gloucester shed bathed in the sunlight of a summer morning and arrived back in Bath at 8.45 a.m.

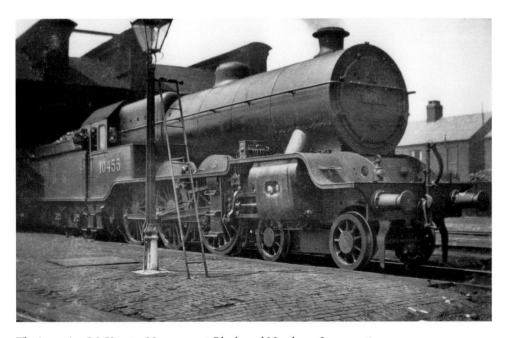

The imposing L&Y 4-6-0 No 10455 at Blackpool North, 20 June 1936.

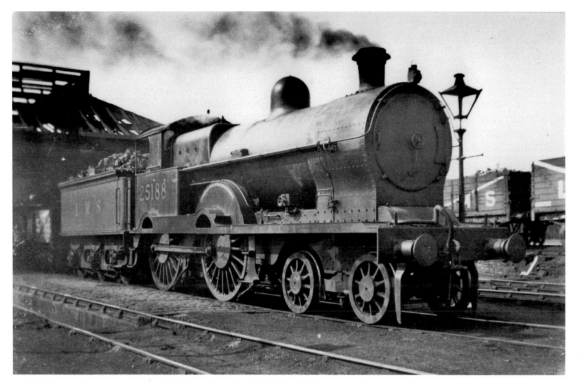

LNWR Precursor 4-4-0 No 25188 *Marquis* at Preston, 20 June 1936.

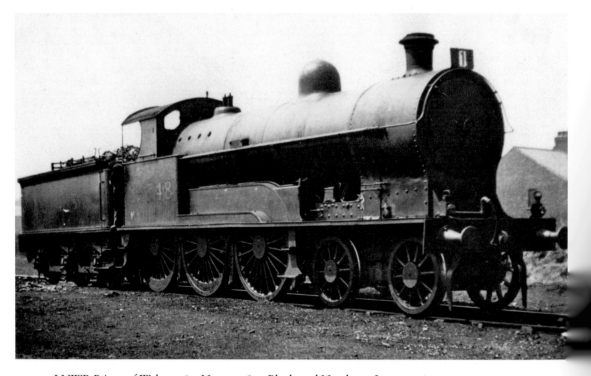

LNWR Prince of Wales 4-6-0 No 25748 at Blackpool North, 20 June 1936.

By a remarkable turn of events he was able to repeat this performance only three weeks later. The church choir in which he sang and where he was assistant organist, wanted somewhere different to visit for its annual outing. Someone mentioned Blackpool. No, it was not Alan, though certainly he did not raise a dissentient voice when the matter was discussed. The only protest came from the vicar who objected to their coming home on the Sabbath and no doubt envisaged a morning service bereft of a choir.

The objection overruled, arrangements were fixed for the trip to take place on Saturday 11 July, though this actually meant that they left Bath at 11.45 p.m. on Friday. They had were given reserved accommodation in a four coach train of corridor stock hauled to Mangotsfield by 0-4-4T No 1408. There these coaches were attached to the main train from Bristol hauled by Black Five No 5096. Alan stayed awake all night and noted that Crewe and its environs were particularly alive and kicking in the early hours. There he gave a whoop of delight when his compartment stopped adjacent to Claughton No 5910 *J.A. Bright,* causing his sanity to be called into question by his companions. His nightly vigil was further rewarded by the sight of three old L&Y 0-8-0s in the Wigan area, Nos 12857, 12962/71. Less than a hundred of this class were then in existence, while their LNWR counterpart stood at over 500 and not one was taken out of service until December 1947.

The train ran into Blackpool North about 7.00 a.m. on a grey, cold morning. A strong smell of rather stale fish pervaded the atmosphere, though for him the unpleasantness was alleviated by the presence of L&Y 0-8-0 No 12905. After an ample breakfast in a promenade café, he jumped on a tram and proceeded along the coast to Fleetwood. Here he found a strong L&Y presence — 0-8-0s, 0-6-0s, 0-6-0STs and 2-4-2Ts. Following an ample lunch at the same promenade café he had patronised earlier, he was determined to return to Preston and see if his impressions of the previous visit were justified. They were and the procession was endless. Under the heading in his note book 'Preston Station. 1.40 — 4.10' is a list of no less than 114 locomotives:

> 23 L&Y 0-6-0s most of these working passenger trains; 18 Standard 4F 0-6-0s; 13 Jubilees (including *Silver Jubilee* in black and chrome finish); 13 Crabs; 7 Royal Scots; 6 Black Fives; 5 L&Y 2-4-2Ts; 4 Compound 4-4-0s; 3 Prince of Wales 4-6-0s; 3 Standard 2P 4-4-0s; a couple each of Stanier 2-6-4Ts, Claughtons, 19 inch 4-6-0s and on each of a Princess Royal, Patriot, George the Fifth, Stanier 2-6-0 and MR 3F 0-6-0.

There was never a dull moment.

Back in Blackpool he joined his companions at the South Shore where from the heights of the roller coaster he espied Claughton No 5975 and 2P No 580 — surely his most unique observation point.

Their return journey from North station was due to leave about 12.30 a.m. on the Sunday. Long before they were due to pull out, a very tired group of choristers sat on a station seat listening to the announcement over the public address system. The train before them was destined for Weymouth and Alan recalls that the Lancashire pronunciation of West Country place names grated heavily on their West Country ears. He made one outstanding note on the return journey, namely the presence of LNWR 4-4-0 No 5334 *Newcomen* at Gloucester shed. Every choir member turned up for Matins — but most slept soundly during the sermon!

Alan had now made five explorations in a row into LNWR and L&Y territory and he did not realise the extent to which he had forsaken his first love of the Midland, until

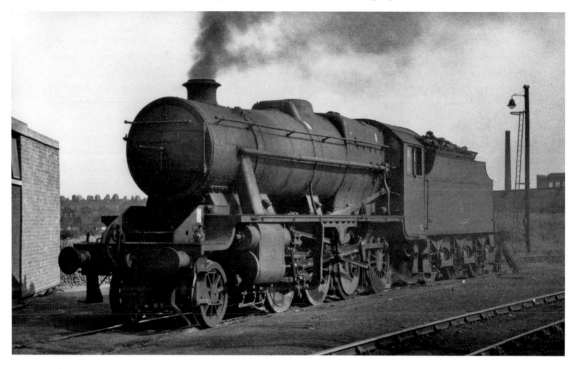

Class 8F 2-8-0 No 48368 at Nuneaton 4 June 1962. A Fowler tender is not usually seen with this class.

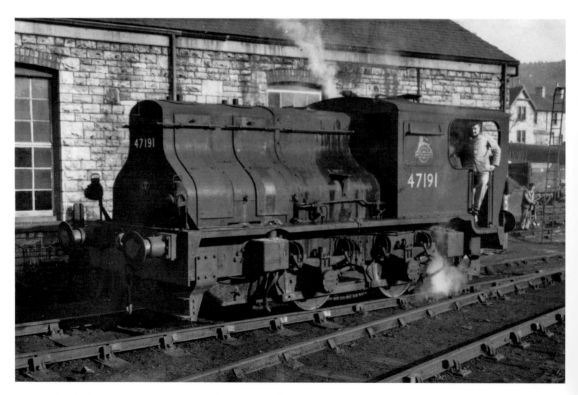

Sentinel 0-4-0T No 47191 at Radstock, 26 February 1953.

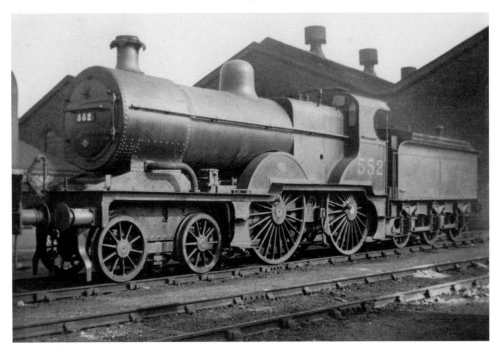

MR 2P 4-4-0 No 552 stored at Wellingborough, 9 August 1936.

he was invited to join an RCTS visit to Nuneaton, Kettering, Wellingborough, Bedford and Leicester on 9 August. The run to Nuneaton was uneventful, the only items of note being two new 2-6-4Ts at Bournville, Nos 2555/6. These carried the recently introduced sans serif style of lettering which to Alan's eyes was rather unattractive and to his joy was soon discontinued.

Nuneaton, the D shed of the No 2 area, was a tidy place and had an interesting allocation. Of the 44 engines there, 25 were LNWR, including 10 0-8-0s, 5 2-4-2Ts, 4 19 inch 4-6-0s and 4 Cauliflowers. There was also a Midland presence in the shape of 6 3F 0-6-0s. There was something of a gap in the proceedings while they waited for a connection to Leicester in order to reach Kettering; then on arrival they were promptly told by the group leader that they had less than ten minutes for the visit. Fortunately the depot was adjacent to the station, but nevertheless it required a lively sprint. There were only 31 locomotives, but it was a real Midland feast and Alan still regrets the fact that it had to be consumed in an indigestible manner. There was one item in particular that he would have liked to have stood and stared at. This was double-framed 2-4-0 No 20012, originally No 12 and, so he was told, deliberately allocated to shed No 12 (as Kettering was before becoming 15B). He found it hard to believe his eyes when he saw her original shed plate still in position on the smoke box door. Other 2-4-0s present were No 20092, recently exiled from Bath, and No 20266. By far the most numerous class was the 2F 0-6-0s of which there were 13. Another familiar engine was ex S&D Sentinel No 7191.

The journey to Wellingborough was by auto train with LNWR 2-4-2T No 6746 of Northampton in command. It was already in position at the platform when they arrived at Kettering, so one of Alan's companions warned the crew as to their intentions and requested a stay of departure until they had done their business. They were as good as their word, though 'certain noises' were made to inform the group that time had run out.

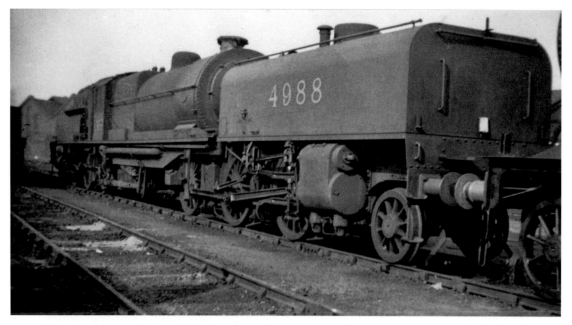

Beyer-Garratt 2-6-0+0-6-2 No 4988 stored at Wellingborough, 9 August 1936.

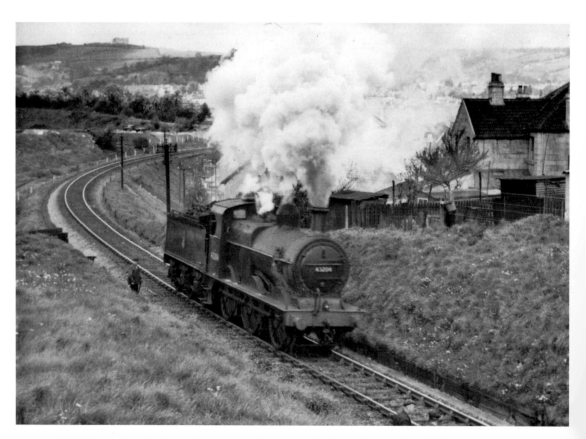

S&D Class 3F 0-6-0 No 43204 leaving Bath ex-works for its home shed, Highbridge, 22 April 1952.

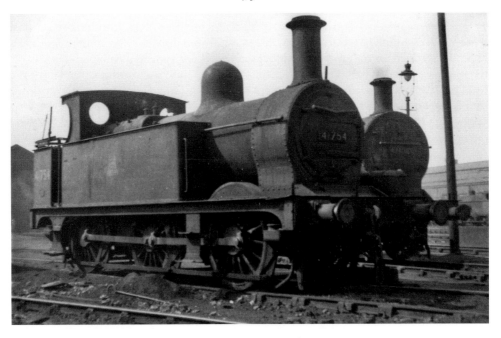

MR 1F 0-6-0T No 41754 at Derby 17 May 1951. Beyond is MR 3F 0-6-0 No 43402.

Wellingborough housed 63 locomotives representing a wide range of motive power. Six Garratts and 6 Standard 0-8-0s were among the larger engines, while at the other end of the scale were 4 MR 2-4-0s, plus 3 0-4-4Ts including No 1230, ex S&D. Bedford had only 26 locomotives, but apart from a new 2-6-4T and a Standard 4F 0-6-0, all were ex-Midland and half of those were 0-6-0s.

They enjoyed a spanking run to Leicester on a glorious summer evening behind Compound No 1117 — the sort of occasion that is easy to recall in the memory and never fails to give great joy in doing so. 15C, Leicester turned out to be the biggest assignment of the day, with some 85 engines. The bulk of this number was made up of 40 0-6-0s, while 13 2P 4-4-0s formed the next largest contingent. Two exiled LTSR 4-4-2Ts Nos 2093 and 2107 were there, while 4-6-0 of Edge Hill formed the solitary LNWR representative. Looking back over the list of 311 locomotives observed that day, it is, perhaps, somewhat remarkable that only 17 were of Stanier design.

For Alan's final outing in 1936 he decided to visit Sheffield and then Staveley. The date selected was 25 October and seeing MR 0-6-4T No 2017 at Burton on Trent and 0-4-4Ts No 1396 at Dronfield and 1395 at Dore & Totley added real spice to the journey. The ride on a Sheffield tram out to Millhouses was pleasant enough. Most of the 40 engines on shed there he had seen before in the Bath-Bristol area. The scene was dominated by 16 2P 4-4-0s including Nos 323/4, ex-S&D. The feature he found most pleasing was the large number of 0-4-4Ts present and at the time there was nothing to suggest that they were to be replaced. The only other tank engine was Stanier 2-6-2T No 113.

Not so pleasant was the tram ride out to Brightside — surely a misnomer if ever there was one! Grimesthorpe was the better alternative. A cloud of dense smoke enveloped the whole area. Of the 72 on shed, 41 were 0-6-0s and 10 Crabs, while the remaining 21 were distributed between nine other classes. From Brightside Alan went on to the darkness of Staveley. Unfortunately extensive repairs to the shed buildings

at Staveley meant the removal of nearly all its locomotive stock into nearby sidings, thereby necessitating a hazardous operation with a small battery torch on a moonless night. He groped around to find 51 locomotives. There appeared to be no one else on the premises so it was an odd experience. There was little variety there, for out of the total of 51, 35 were 3F and 4F 0-6-0s, 11 were 0-6-0Ts and 4 were Standard 0-8-0s. The odd man out was MR 0-4-0T No 1534.

Looking back at Alan's 1936 diary of movements in the Bath-Bristol area there were fewer red-letter entries. 2-4-0 No 157 which had already gone to Walsall, turned up on 22 January with the Engineer's Saloon just in time to exchange greetings with No 20092 before she left for Kettering. On 8 February the Bath shunter, 0-6-0T No 1870 went to Gloucester, her replacement being S&D No 7316. The first pigeon special of the year was noted on 2 May and during the weeks that followed through to September, came the usual procession, every single one behind a 4F 0-6-0, several of them double-headed. Once again they came from a variety of sheds, with Goole, Plodder Lane and Hellifield amongst the fresh ones. On 27 May he recorded a mass exodus of the S&D 4-4-0s. Nos 322/3/4 went off to Millhouses, and Nos 325/6 to Saltley. In their place came Nos 600/1/2/99 and 700. On 15 July 0-4-4T No 1251 arrived from Manningham and became part of the local scene for some time. Diary entries during July and August reveal the usual build-up of traffic with something like 90 locomotives at Bath on a Saturday.

Chapter 6

1937

1937 was a Derby year. Alan went there from Bath for a half-day on two occasions and was resident there for a whole week in August. The brother of a friend had been appointed to a post with the Sanitary Engineer's Department of Derby Corporation and his loquacious landlady welcomed all comers at a modest charge. To be actually waking and sleeping within the sight and sound of the heart of the Midland Railway was something he had never reckoned himself to be fortunate enough to experience.

The first half day visit came on 28 February. He cannot remember why he decided on this venture unless it was to see a couple of Jumbos on the scrap road. If it was to celebrate the approach of spring, then he had made a bad miscalculation, for just north of Birmingham he ran into an almighty blizzard which put paid to his plan to stop off at Burton on Trent for a quick tour of the shed. At Derby station he froze in the waiting room waiting for the skies to relent. Eventually they did so and by mid-afternoon a thaw had set in. The sheds and adjoining yards were almost full to capacity with something like 200 locomotives. The most common type was 0-6-0 of which there were 85. New Stanier engines only totalled 20. He was delighted to discover 6 2-4-0s No 20012, 207/53 from Kettering, 20087 from Carlisle (Upperby), 20115 from Bedford and 20254 from Walsall. The unique thing about this occasion was that all the extant Midland classes were represented, even though some of them were only in ones and twos, such as 0-4-0T No 1509 Works Shunter, double-framed 0-6-0 No 22849 and 0-6-4Ts 2023/34. The only pre-grouping non-Midland stock comprised 4 LTSR 4-4-2Ts Nos 2092/4/5 and 2143; 2 L&Y 0-6-0 Nos 12115/29 from Normanton and North London 0-6-0T No 27515.

Before his week's stay in Derby in August, he devised a day's outing to cover all the depots in Area 5 — Crewe, Stafford, Stoke, Alsager and Uttoxeter. In the end the last one on the list had to be omitted through lack of time. Even in later years he never found his way to 5F. The run to Stafford behind Compound No 1029 produced no startling sightings, but Stafford was a hive of LNWR 4-6-0s — 5 Prince of Wales and 3 19 inch Goods. LNER J6 0-6-0 No 3551 looked like an egg in the wrong nest.

Crewe South displayed 66 locomotives and Crewe North 85. The Stanier invasion was particularly marked at the latter shed. 18 Jubilees and 13 Black Fives made up more than a third of the total. The LNWR contingent had diminished dramatically to less than one eighth, with the tender engines down to three. An unusually high proportion of Royal Scots were there — fourteen in all — but the shed staff expected visitors to ignore everything else in favour of their new baby. Shimmering in the sunlight of that beautiful June afternoon was Crewe's response to the event of the year — No 6220 Coronation in her blue and white strip. Alan performed the expected obeisance.

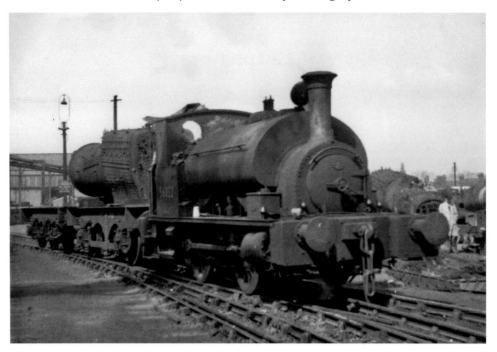

Caledonian Railway 0-4-0ST No 56032 at Crewe Works 17 May 1951. It is hauling a boiler and smoke box on the frames of two old tenders. More boilers and smoke boxes are to the right.

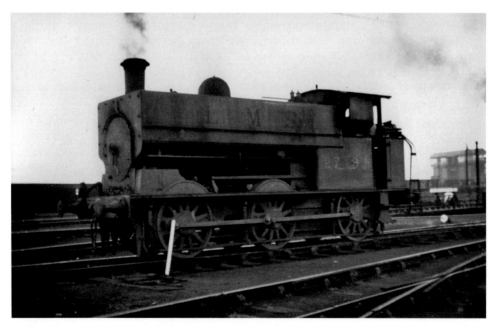

LNWR 0-6-0ST No 27492 at Crewe North, 22 August 1938.

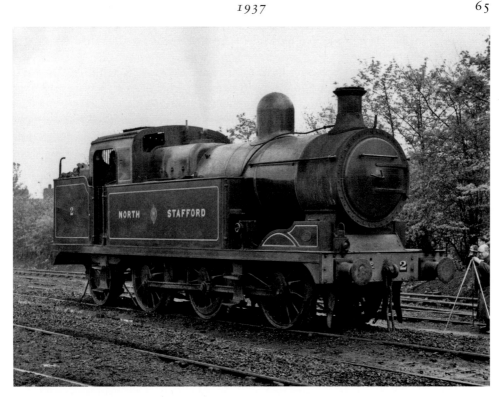

North Staffordshire Railway 0-6-2T No 2 at the NCB Walkden colliery, 21 May 1963. Ivo Peters is on the right filming it.

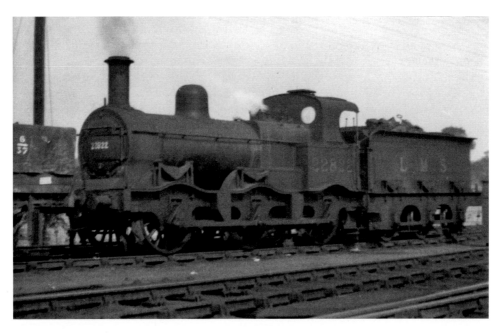

MR double-framed 2F 0-6-0 No 22822 at Tamworth, 26 August 1939.

Standing right beside her was No 6200 *Princess Royal*, the twos of them making a magnificent picture.

Alsager was a complete contrast having just 8 4F 0-6-0s and 3 Jinties. The only relief from their monopoly was LNWR 0-8-0 No 9263 from Coventry. It was the next port of call where he had anticipated finding his most interesting material of the day, but Stoke on Trent, hearth and home of the former North Staffordshire Railway was now virtually bereft of her children. Alan had arrived too late. Only 6 were left and these were 0-4-4Ts Nos 1434/6; 0-6-0T No 1570; 0-6-2Ts Nos 2270/1 and 0-6-4T No 2046. Every one of these had gone by the end of the year, their demise hastened by the injection of new 2-6-2Ts and 2-6-4Ts into the area. Stoke shed on 13 June 1937 held 63 engines; thirty years later on 30 April 1967 Stoke was one of the last steam centres he visited and even then, 47 were there.

His week's residence in Derby began on 7 August and to reach it he took his first ride on the Pines Express. On the way 2 MR double-framed 0-6-0s Nos 22579 and 22630 newly-transferred to Bournville gave a good start to the proceedings. The following day he went to Burton on Tent to make up for the first visit buried by February snow. The shed was comfortably filled with 62 engines and one or two little surprises, including his first confrontation with a Caledonian specimen in the shape of 0-4-0ST No 16020. Three MR 0-6-4Ts were there all destined for the scrap road. In the yard LNER J6 0-6-0 No 3536 caught his eye.

Returning to Derby Alan had the luxury of browsing around without having to worry too much about the clock, so stayed until lighting-up time. He listed 174 locomotives on shed distributed amongst 27 different classes. The various 0-6-0 tender types produced 77. Topping the list of other classes were 16 Compound 4-4-0s. Stanier was represented by 10 Black Fives, 5 Jubilees, one new 8F 2-8-0 and one of his very first class, 0-4-4T No 6403 from Manningham. Older engines included 2 North London 0-6-0Ts Nos 27506/23 and MR 2-4-0 No 20242 from Peterborough. No 20225 had passed through the works and was being returned to Kettering. He noticed that an increasing number of Midland smoke boxes were being adorned with the new Stanier chimney. He found no cause for rejoicing in this change of appearance.

The following day he travelled to Tamworth to meet in person an enthusiast with whom until then he had only met through correspondence. Tamworth offered the best of two worlds: a main Midland line crossing a main London & North Western. They

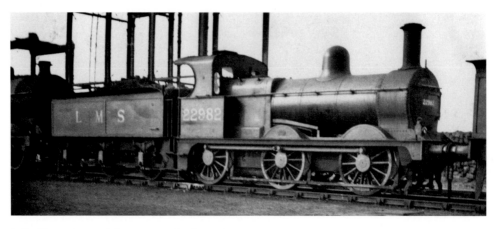

MR Class 2F 0-6-0 No 22982 at Derby, 8 August 1937.

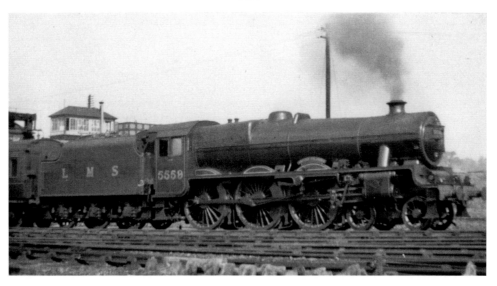

Jubilee 4-6-0 No 5559 *British Columbia* at Tamworth, 26 August 1939.

spent a pleasant hour or two by the lineside and this afforded him the opportunity to see engines with the regulator right over. It was quite exhilarating. Royal Scots appeared most frequently, (15 examples) and there were the Up and Down Coronation Scot headed respectively by No 6220 *Coronation* and No 6224 *Princess Alexandra*. Turbomotive No 6202 slid silently by on a Down express. Was this, they wondered, the shape of things to come? It was not to be and No 6202 rebuilt as an orthodox machine and named *Princess Anne,* was to come to a sorry end in the Harrow disaster 25 years later. 82 engines covering 20 different classes bore witness to the amount of activity which could be seen in the space of a couple of hours at this busy crossroads.

On Wednesday 11 August Alan set out for Manchester. He had been given to understand that Victoria station was a good place for variety and entertainment, so there he went to partake of the spice of life. His platform vigil lasted from about midday until 3.30 p.m. during which time 127 locomotives appeared covering 23 classes. Although L&Y 2-4-2Ts seemed to be handling a fair amount of the local passenger traffic, Fowler 2-6-4Ts and 2-6-2Ts had an equal share in the proceedings. Only 4 Stanier tank engines appeared, but Jubilees and Black Fives accounted for as many as 37 sightings. Crabs were well towards the top of the list, while at the bottom stood just one LNWR 4-4-0, Precursor No 25298 of Patricroft. Four Hughes' 4-6-0 Nos 10423/9/32 from Blackpool and No 10448 from Accrington were in action and Alan was particularly pleased to see 4 Baltic tanks, Nos 11113/4 from Agecroft and Nos 11115/7 from Bolton.

On his return to Manchester Central he experienced his first real encounter with the strange world of the LNER and by no means did he dislike what he saw. 4-4-2Ts held the stage with C13 Nos 5018/20/2/8/47, 5114/71/99, 5453/4, 6055/7 and C14 No 6121. Three classes of 4-6-0 appeared: B8 No 5444, B9 No 6105 and B19 Nos 5624/7 as well as 4-4-0 D9 No 6033, D10 No 5429, J10 0-6-0 No 5836 and F1 2-4-2T No 5582. Having been accustomed to an orderly numbering scheme in GWR and LMS circles, that of the LNER was to his mind something of a shambles, yet when eventually a comprehensive renumbering scheme was introduced in 1946, one could not help feeling that some of the fun had gone out of the system.

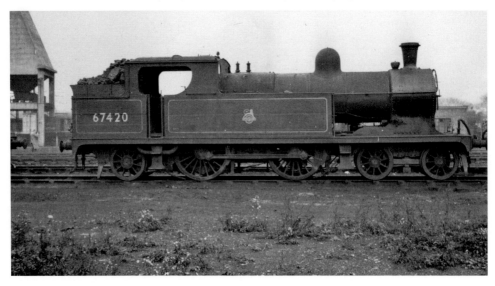

GCR C13 4-4-2T No 67420 at Neasden, 18 October 1953.

Thursday 12 August saw Alan travelling to Nottingham where he was given leave by a kindly foreman to look round the locomotive shed. This was his first visit since that glorious day in June 1934. Despite its being a weekday, there was the surprising number of 60 engines on shed. The only significant change since the previous visit was the presence of several Black Fives, 2 Jubilees, 2 2-8-os and a couple of LTSR 4-4-2Ts, but it was still very much a Midland preserve. There was a good deal of activity in and around Nottingham station, so in order to enjoy it he deliberately missed the train he had intended to catch back to Derby. His decision was amply rewarded by the arrival of MR 2-4-0 No 20219 from Peterborough. Nottingham's own No 20183 was working, while Mansfield's LTSR 4-4-2Ts Nos 2104/9 appeared. The LNER offered a contribution in the shape of Midland & Great Northern J3 0-6-0 No 086.

His choir outing that year took the form of a day in London. On arrival at Paddington it was decided that each should do their own thing and then meet for tea and an evening show. Alan's plan was to prove to himself that he had truly become ecumenical in his outlook and so embarked on a tour of a number of termini. He paid his first respects to Euston where apart from seeing 4-6-2 No 6222 *Queen Mary* in her Coronation outfit, nothing else caught his eye. St Pancras held no surprises, but then he crossed the road to King's Cross and for the first time saw in the flesh a GNR Atlantic (No 4450) and an A3 Pacific (No 2554). His first impression of the latter was that it appeared rather lean and slender — almost delicate — compared with its LMS counterparts. Nearly everything else that moved seemed to be an N2 0-6-2T. True this was only a fleeting glance, but the ice was beginning to break.

He looked in at a quiet Fenchurch Street where there were just 3 LMS 2-6-4Ts and 2 LNER 2-4-2Ts which rather took his fancy. Alan then went on to Jintyland, ie Broad Street where, amongst the 14 that appeared in record time came No 7314 of S&D memory. A cursory glance inside Waterloo produced 15 items distributed amongst 10 classes. The celebrated Royal Train T9 4-4-0 No 119 was there as were 2 T14 4-6-0s Nos 444/84.

Without any doubt, the biggest revelation of the day was Liverpool Street with its intense volume of traffic. Alan was there for little more than half an hour but noted

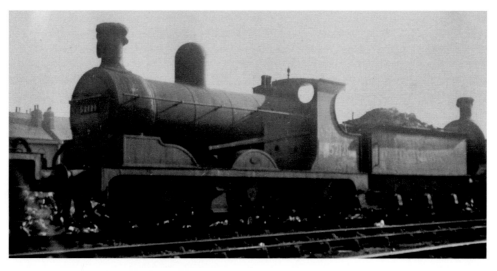

L&Y 0-6-0 No 52121 stored at Nottingham, 17 May 1951.

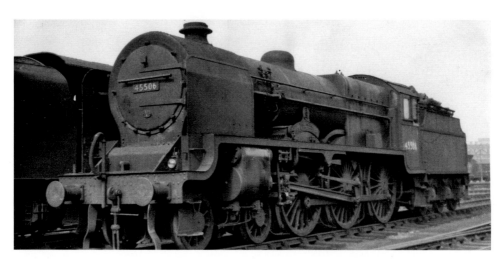

Patriot No 45506 *The Royal Pioneer Corps* at Nottingham, 11 September 1955.

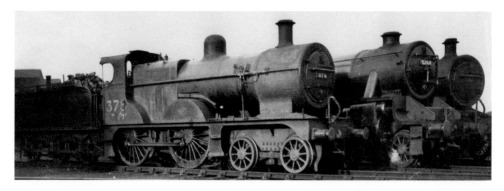

Un-rebuilt MR 2P 4-4-0 No 378 at Derby 8 August 1937. Beyond is Class 5 4-6-0 No 5268 and 2P 4-4-0 No 630.

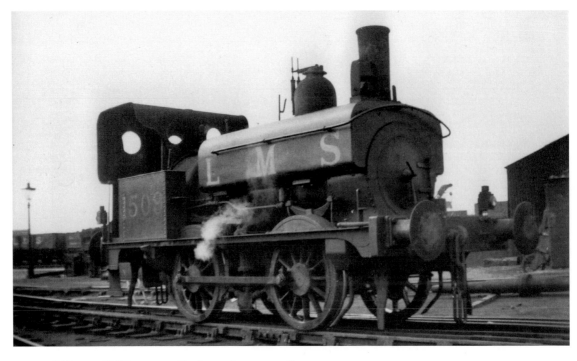

MR 0-4-0ST No 1509 at Derby, 23 August 1938.

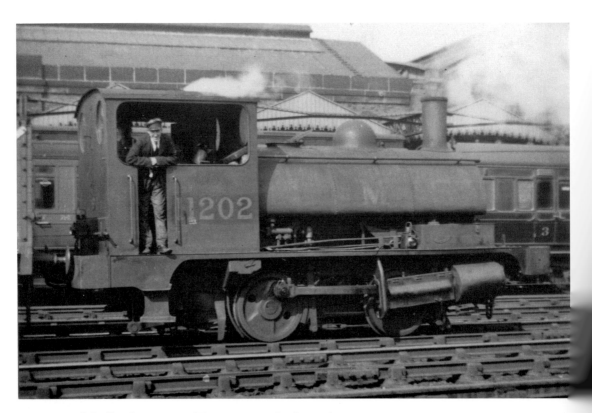

Dumb-buffered L&Y 0-4-0ST No 11202 at Derby, 23 August 1938.

no less than 50 engines in that time. One third of this total comprised N7 0-6-2Ts. A dozen Sandringham 4-6-0s appeared as did half a dozen each of B12/3 4-6-0s and Claud Hamilton 4-4-0s. These engines were very well turned out and it was at this time, date and place that Alan realised that he had been missing out on something good, so he resolved to wash some of the LMS image from his vision. Unfortunately he had left things a bit late and it was not until after WW2 that he was able to convert his resolution into action. A magnificent fish and chip supper in a colourful restaurant in the Edgware Road with his fellow choristers against the background of Henry Hall's BBC Dance Band, (incidentally their last radio performance as such), rounded off a day of great interest.

For his final trip for 1937, on 24 October he returned to Derby. He made a round of the sheds and yards and certainly seeing the bumper number of 212 engines made the trip well worthwhile. 28 different classes were represented with 0-6-0 tender types reaching the 100 mark. The next largest group was provided by Compound 4-4-0s with 21 examples. On the condemned line were MR 0-6-4Ts Nos 2003/25/8; 2-4-0 No 20242; 0-6-0T No 1819 and Glasgow & South Western 0-6-2T No 16919. A number of new locomotives were in evidence: 11 Jubilees and 7 Black Fives headed the Stanier contingent, while 3 new 4F 0-6-0s Nos 4565/74/5 recently out of Crewe merged with their older brethren and looked anything but new.

Alan's local diary entries for 1937 had a very quiet start with only notes about familiar engines returning from works with Stanier chimneys and new-style lettering, concerning which his little group of enthusiasts were at one in their disapproval. Sunday 11 April achieved headline status when LNWR Cauliflower 0-6-0 No 8594 arrived hauling a crane from Walsall. This must have been the first appearance of the class at Bath. On 6 June Alan made a trip to Bristol Barrow Road — his first visit on a Sunday. His full list recorded:

> 2P 4-4-0s Nos 396, 422, 510/2/20/3/4, 602; Compound 4-4-0 No 1027; MR 0-4-4T Nos 1267, 1337/8/64/89/97, 1404; MR 0-6-0T Nos 1706, 1815; MR 3F 0-6-0 Nos 3181/6, 3436/9/44/62/4, 3727; 4F 0-6-0 Nos 3873/6/98, 3982, 4013, 4170, 4272/3/7, 4534/6/59; Black Five Nos 5043, 5289; Jubilee No 5609 and Jinty No 7316.

On Friday 2 July 2-4-0 No 20008 of Walsall ran light into Bath at 7.30 p.m., stayed over the weekend and left on Monday. The why and wherefore of this incident remains a mystery, but it was nice to have the chance of a leisurely look at this Kirtley veteran which he was able to photograph on Leicester shed turntable as MR No 158A over 30 years later. On 23 July another surprise visitor appeared: LNWR Cauliflower 0-6-0 No 8619 from Burton on Trent stood by the Midland shed at Bath in the evening light and caused a further buzz of excitement among local enthusiasts. Once again the circumstances surrounding this movement were not discovered, though probably all these strange goings-on were connected with the rebuilding of the river crossings between Bath and Mangotsfield.

In the space for Tuesday 5 October he wrote the heading 'The shape of things to come' and underneath it placed the announcement: 'NOTICE TO ENGINEMEN, OCTOBER 1st:- The Engineer has agreed to the following Standard types of engines working between Mangotsfield and Bath subject to speed restrictions of 15 m.p.h. only over bridges 19 and 24. Compounds, Class 5P 4F 4-6-0, Class 5P 5F 2-6-0 (Taper and Parallel).' On Saturday 16 October they came. Black Five No 5274 of Saltley arrived at Bath 7.25 a.m. hauling empty passenger stock and left at 8.00 a.m. with a Blackpool excursion. This was the first recorded visit of this class to the city. Later the

same day Compound 4-4-0 No 1001 arrived with the Down Pines Express, while No 1025 drew an Evening Excursion (EVEX for short) to Birmingham at 5.00 p.m.. The following Saturday Compound No 1071 of Leeds headed the Up Pines Express, while on Tuesday 30 November Black Five No 5271 was the first of its class seen in action on that particular turn. The remainder of the notes for that year were concerned chiefly with the movement of Compounds and Black Fives which established themselves very quickly on all the rosters previously in the hands of 2P 4-4-0s.

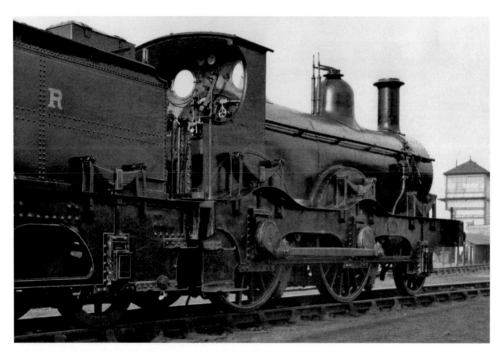

MR 2-4-0 No 158A preserved at Leicester, 26 February 1968.

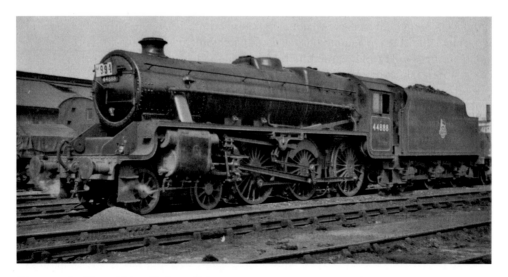

Class 5 4-6-0 No 44888 at Bath, 29 July 1951.

Chapter 7

1938

Most people who were not completely without foresight knew that it would not belong before the balloon went up in Europe. The phoney Munich Agreement merely transferred the inevitable from 1938 to the following year. Alan's railway activities suffered a decline during this final complete year of peace, mainly because he became heavily engaged in preparations for Holy Orders.

His first railway outing did not take place until Easter Monday 18 April 1938 when he visited Toton. For once the traditional English Bank Holiday weather failed to live up to its normal reputation. It was a glorious spring day, recalling memories of that previous visit in June 1934. He had no permit on the 1938 occasion, but by extreme good fortune another party had just arrived and the kind shedmaster included him. With 144 engines in residence there was plenty to see. The most significant change of scenery was provided by the presence of new Stanier 8F 2-8-0s of which there were 21. Nevertheless 0-6-0 types numbered 76, while 20 Garratts and 10 Standard 0-8-0s remained on the establishment. The Glasgow & South Western 0-6-2Ts were still there, though their number was depleted to 3. In Nottingham station he found a couple of LNER J11 0-6-0s; B8 4-6-0 No 5443 and C4 4-4-2 No 5265.

A week's holiday at the end of August gave Alan a chance to set up a temporary operations base at Tamworth. His first main target was to be in the Manchester area with Newton Heath as the principal point of interest. A visit to 26A, (the former No 1 shed of the old Central Division), was long overdue. 134 engines distributed amongst 19 classes awaited him, 64 of which were of L&Y origin. Over half of the L&Y contingent were 0-6-0s, while two other classes with a strong presence were 0-6-0STs and 2-4-2Ts. Other classes with numbers running into double figures were Standard 0-8-0s, Fowler 2-6-2Ts and Black Fives. The most delightful sight of all was that provided by Baltic tank No 11110 of Agecroft.

The next port of call was Patricroft which he remembers as a rather messy sort of place. For a 'C' shed however, it had a fair allocation and 6 engines awaited his arrival, but apart from 16 LNWR 0-8-0s there was little to remind him of its former history. The same situation obtained at Longsight where the LNWR representation was down to six. It was very much a 'Standard' shed, the only other pre-grouping stock in the 69 being of Midland origin namely Compounds 0-4-4Ts and 3F 0-6-0s.

London Road station produced a couple of LNER C13 4-4-2T Nos 5357 and 5457 and MR 0-4-4T No 1416 from Buxton, but Alan remembers this terminus more for another reason. It is true that he had great difficulty in interpreting the language of the porter who directed him to the wrong train, but he cannot recall this incident without a sense of shame. He had no intention of going to East Didsbury, but he was very smartly

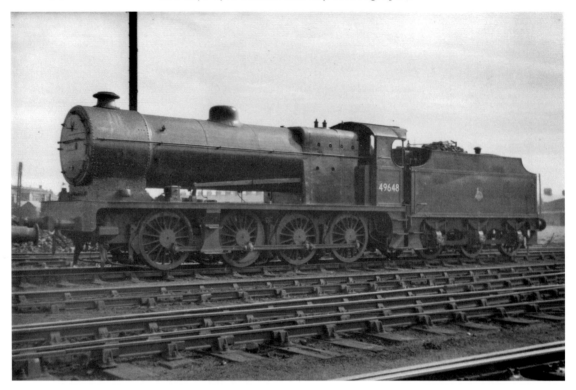

LMS Class 7 0-8-0 No 49648 at Blackpool North, 19 July 1952.

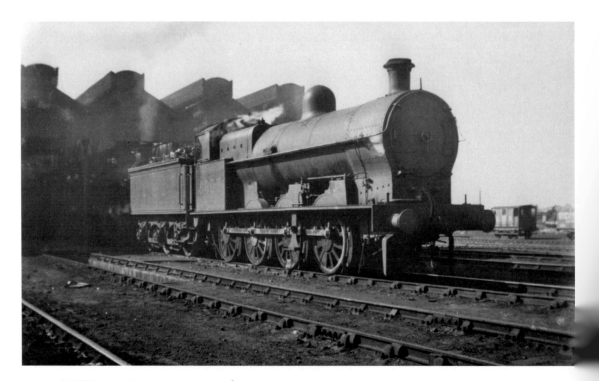

LNWR 0-8-0 No 8903 at Patricroft, 21 August 1938.

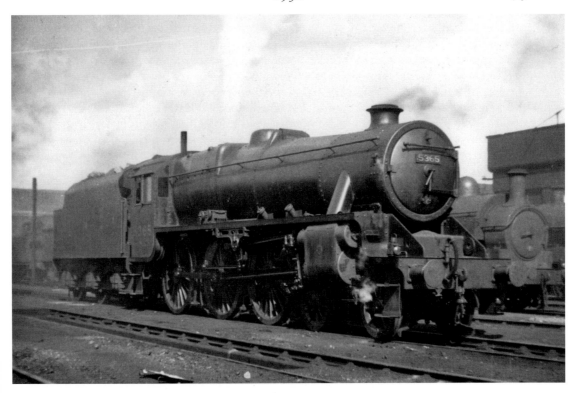

LMS Class 5 4-6-0 No 5365 at Patricroft, 21 August 1938.

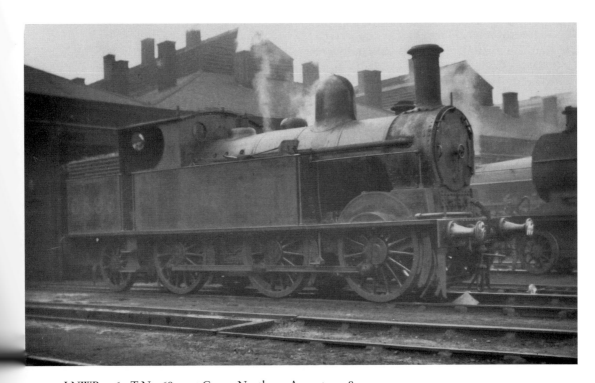

LNWR 0-6-2T No 6893 at Crewe North, 22 August 1938.

taken there behind a Fowler 2-6-4T. He made his escape and reached Stockport in time to join the correct train to Tamworth. Despite Manchester's reputation for inclement weather, 21 August 1938 was a truly beautiful day and even a night out on the platform at East Didsbury would not have been unpleasant.

Monday 22 August saw him travelling to Crewe, the intention being to spend a morning browsing around the station and North and South sheds before embarking on a tour of the works, which was for him a new venture. Observations in and around the station produced 80 items, the greater proportion of which consisted of Princesses, Royal Scots, Jubilees and Black Fives. Only one LNWR 4-6-0 arrived on the scene, No 25841 from Stafford, but three 4-4-0s, Nos 25188, 25310/92 came in to show the flag, albeit at half-mast in this heart of the North Western. North shed contained 50 engines, the only noteworthy items being 3 LNWR 2F 0-6-2Ts Nos 27664, 7711/57, from Bangor. Engines were thin on the ground at the South shed and apart from two Dock Tanks from Birkenhead, Nos 7100/4, nothing else among the 46 gave cause for special comment.

He presented himself at the Works entrance, or rather one of them, at 2.30 p.m. and immediately sensed the air heavy with proud tradition, which he found wanting on a return visit 20 years later. Within the confines of the Works were 75 locomotives, amongst which were a fascinating array of veteran pieces in the Service Department — 0-4-0T No 3009, 0-4-2 Crane Tanks Nos 3247/8/9, 0-6-0ST No 3323, 0-6-2T No 7592, 7724, 0-4-2ST No 7865 and Coal Engines Nos 8100/6/41, 8227, 28091 and 28115. In the paint shop — always so beautifully quiet — in company with 2 Jubilees and 2 Black Fives stood *Cornwall* and *Hardwicke*, the latter still with its LMS No 5031. The bulk of the items around the Erecting Shop consisted of Princesses, Royal Scots and Jubilees. Turbomotive No 6202 was there and obviously in a lot of trouble. No 6229 *Duchess of Hamilton* stood resplendent in the portals of the Erecting Shop. As his train pulled out of the station, GWR Mogul No 8390 stood at the south end of the station looking quite out of place.

The next day Alan visited Derby and found it rather disappointing, but perhaps this was only to be expected as he had rather overdone that centre the previous year, so 24 August proved a much more interesting day when he made a half-day booking from Tamworth to Euston. The sun looked down from a cloudless sky to add to the pleasure and delights of the journey. The first moment of joy came at Atherstone with the sighting of Claughton 4-6-0 No 6004. Bletchley came up trumps with three Prince of Wales 4-6-0s Nos 25673, 25804/45, but an L&Y ingredient had now crept into this North Western stronghold for 0-6-0ST No 11342 and 0-6-0s Nos 12107/76 were there. Alan noted 103 locomotives on the run to Euston and an analysis shows they covered 25 classes proving that there was still a remarkable variety of motive power in existence. On arrival in London he made his way over to what could be called one of its lesser known railway areas, namely Plaistow and Devons Road (Bow).

In and around Plaistow some 50 engines were visible. Of these, 15 were 4-4-2Ts and an equal number of Stanier 3-cylinder 2-6-4Ts. Four LTSR 0-6-2Ts were on shed, a class which never went outside its home territory. Two MR items were allocated to the shed: 0-6-0T No 1718 and 2F 0-6-0 No 3358, but what gave the greatest pleasure was a visitor from Upminster, 0-4-4T No 1216. Devons Road shed had an allocation that was unique in so far as the bulk of it consisted of Jinties used for suburban passenger work. These locomotives could also be observed frequently at Acton on exchange freight duties and Alan recalls that almost without exception they were maintained in excellent condition. Forty engines were on shed when he arrived in the evening and all but four, 3 MR 0-6-0s and a Stanier 2-8-0, were tank engines. Apart from

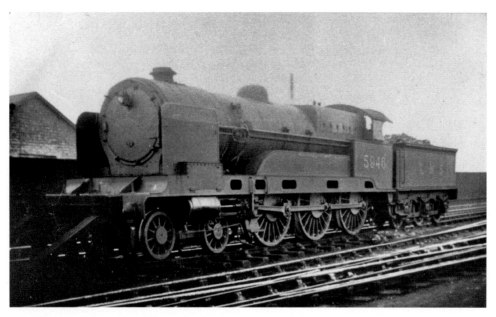

LNWR Claughton No 5946 *Duke of Connaught*, rebuilt with Caprotti valve gear in June 1928 and withdrawn February 1941.

the Jinties, there were North London Railway 0-6-0T Nos 27513/14/17/25/28/32 and 0-4-2 Crane Tank No 27217. By an interesting coincidence, in the re-numbering scheme, some of the Jinties had been given the original numbers of the North London engines. Nos 7513/4 stood alongside Nos 27513/4! Two Stanier 2-6-2T Nos 82 and 105 had come on to the strength of Devons Road, but their presence made little impression on the depot.

The day following his trip to London, he had to travel to Southport 'to see a man about a dog collar', so by making an early start from Tamworth he was able to give himself enough time for a short session at Preston. This particular journey was one of the most pleasurable of all his trips.

Alan had a compartment all to himself, so he settled down in his seat and placed his feet on the one opposite, having dutifully removed his shoes before doing so. Thus he could relax in a world of living steam and what a marvellous panorama it proved to be on that sultry summer's day. Well over 200 items went into his notebook, covering no less than 33 different classes. On that occasion Warrington was unusually alive and 8 L&Y 0-6-0s in the vicinity of the shed included 5 newly-allocated there (Nos 12111, 12269, 12338/66/7), and with them was shed-mate MR 3F 0-6-0 No 3457. In the station environs stood George the Fifth 4-4-0 No 25324 which Alan had not met before and GWR Moguls Nos 8302/44; these last two, to his mind, were trespassing too far into northern territory.

The Wigan area had steam in abundance, mostly L&Y 0-6-0s and LNWR 0-8-0s, but the most memorable thing he saw there was three LNWR 0-8-2Ts in action — Nos 7881/4/98. Preston provided its usual marvellous variety of motive power, so within the space of an hour he was able to take note of some 80 items. Only 18 of these were on shed, two of which were Preston's own Royal Scots Nos 6132/58 in beautiful condition. For sheer delight to the eye Alan believed there was little to beat an original Scot which had been through the hands of diligent cleaners. Hughes' 4-6-0 Nos 10442

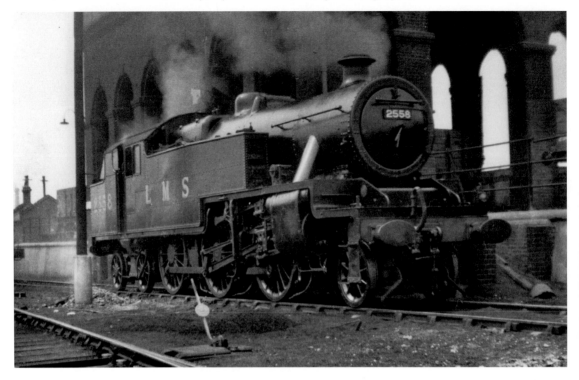

Stanier 4P 2-6-4T No 2558 at Plaistow, 23 August 1939.

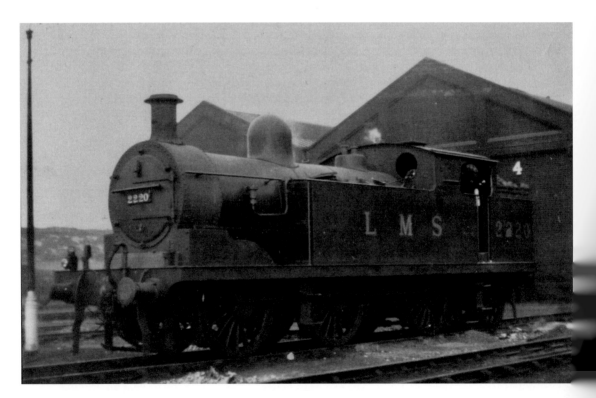

LTSR 0-6-2T No 2220 at Plaistow, 24 August 1939.

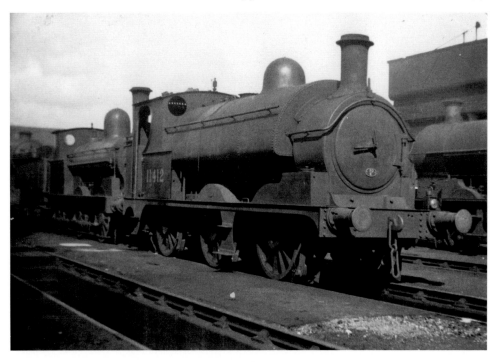

L&Y 0-6-0ST No 11412, shedded at Sutton Oak, at Patricroft, 21 August 1938. Behind is LNWR Coal Engine No 8288.

from Accrington and 10455 from Blackpool arrived, though neither had been given the same treatment. In due course, Alan was surprised to discover that No 10442 ended her days at Motherwell, of all places, in September 1950.

Alan lacked the opportunity to see much of what was happening in Southport, but took in that it was a very busy centre with an overwhelming L&Y presence. Eighteen 2-4-2Ts and 5 0-6-0s left little others out of the 32 locomotives seen in the course of entering and leaving the station.

For the final day of his holiday, 26 August, he elected to go to Normanton and Wakefield. the former was the meeting-place of the Midland, L&Y and the North Eastern. The Midland presence accounted for almost half of the 56 engines seen and was unusual in that the 7 0-6-0Ts were of the older variety, with not a Jinty in sight. The L&Y provided 8 items, 3 of which were 0-8-0 Nos 12171/53 of Normanton and No 12910 from Huddersfield. The North Eastern was represented by B15 4-6-0 No 822, J26 0-6-0 No 1130 and J71 0-60T No 1155. At Wakefield there were some 50 engines on shed, a fair gathering for a Friday midday. 19 of this number were Standard 0-8-0s and the bulk of the remainder consisted of L&Y 2-4-2Ts, 0-6-0s and 0-6-0STs. The L&Y 2-4-2Ts monopolised the local passenger turns, with Stanier 2-6-2T No 147 from Farnley Junction and No 163 from Huddersfield being the only exceptions. The journey back to Bath on 27 August was entirely without incident, but after having seen 1,700 locomotives during the week, that mattered little.

The church choir decided on Blackpool for its 1938 annual outing. Alan was rather blasé about the run up to Lancashire and must have slept most of the way as he hardly noted a thing until Preston. In the grey light of a chilly autumn morning he picked out Baltic tank No 11117, (which was to prove his last sighting of the class) and several

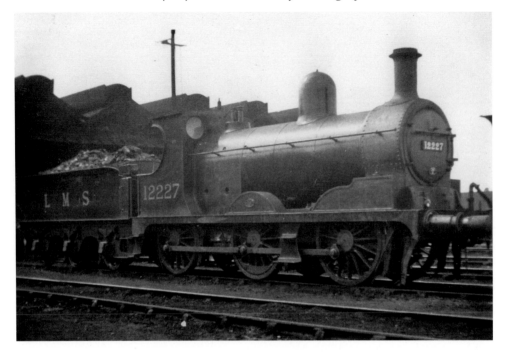

L&Y 0-6-0 No 12227 at Newton Heath, 21 August 1938.

L&Y 0-6-0s and 2-4-2Ts. Blackpool Central presented an unaltered picture and the same unpleasant odour, but even at 7.00 a.m. there was a good deal of activity to be seen. Among the interesting early birds were 2 Crabs from Abergavenny, Nos 2778/88 which had brought a Welsh contingent to savour Blackpool's delights. At a more civilised hour, several other excursions arrived, mainly behind Black Fives, Standard 4F 0-6-0s and L&Y 0-6-0s. Alan's quick run to Preston and back before lunch was well worthwhile as he was able to see 2 4-6-0 types for the last time — Hughes' Nos 10429/37 and LNWR 19 inch No 8859.

Alan's local notes for 1938 were thin compared with those for previous years. The days of copious note-making on activities seen were on the wane. January contained only two notes: MR 0-4-4T No 1392 arrived from Millhouses on the 9th and left for Highbridge a few days later. On 29th an S&D 2-8-0 was seen ex-Derby Works sporting a Stanier chimney and so bore the dubious distinction of being the first of its class to be so adorned. On Friday 11 March Black Five No 5288 from Bristol left Bath at 9.00 a.m. on a test run to Bournemouth. The outward load was 265 tons, and the return load at 4.00 p.m. 400 tons. All would appear to have gone well, for at the end of April came the announcement that 6 Black Fives were to be allocated to Bath for S&D duties to start work on 2 May. Nos 5023/9, 5194, 5389, 5432/40 all arrived by the end of April. Together with these came Stanier 2-6-2Ts Nos 179/80/1 for banking duties and local S&D and Midland passenger turns. This contingent of 9 new engines was sent to replace 16 of the smaller types, so on Sunday 1 May a line up of several 2P 4-4-0s by the Midland shed was evidence that Bath was about to prune some of its older material.

Saturday 14 May saw the first of the season's pigeon traffic and for the first time Black Fives were noted on these trains as well as the usual 4Fs. During the summer months of 1938 this line of business brought to Bath an unprecedented variety of

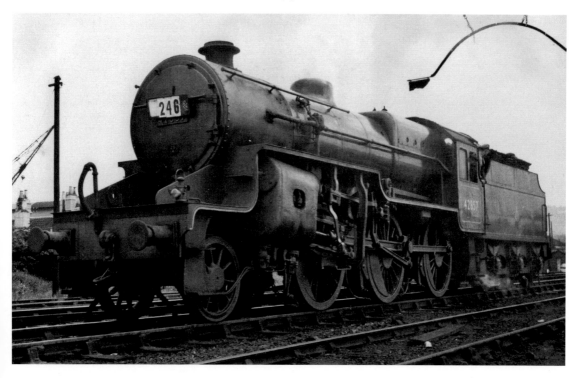

Crab 2-6-0 No 42857 at Bath, 16 August 1952.

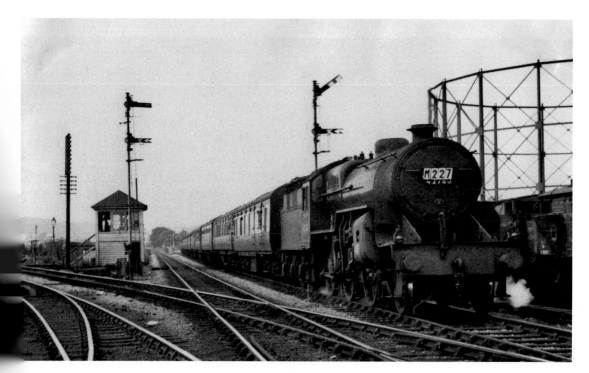

Crab 2-6-0 No 42760 (17D Rowsley) passes Bath Junction with a train to Bath and Bournemouth West, 30 July 1955.

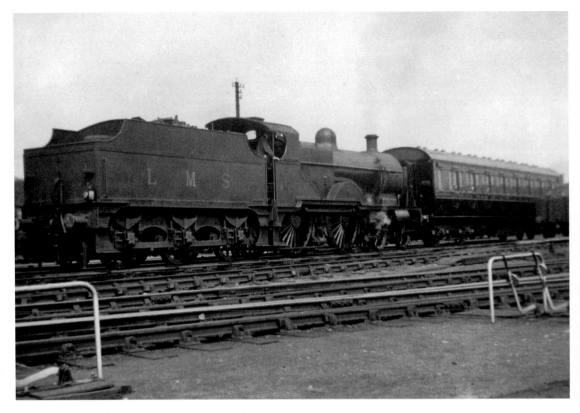

MR 4-4-0 Compound No 1001 at Bath July 1938.

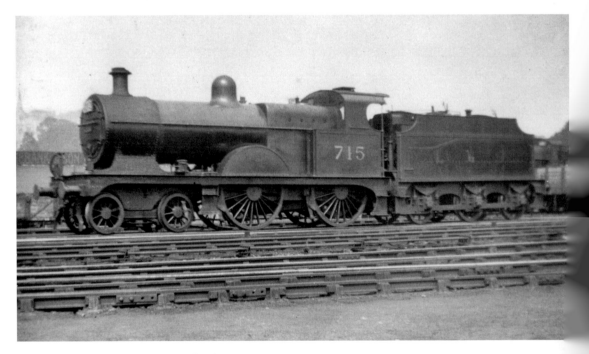

MR 3P 4-4-0 No 715 at Bath July 1938.

motive power. Black Fives came in greatest numbers from Crewe, Longsight, Preston, Carnforth and Southport, and the force of 4Fs was much reduced as a consequence. Three Crabs were noted, while Stanier 2-6-0 No 2958 from Edge Hill was recorded as the first of its class to arrive in the city. The most unusual occurrence however, was the double-heading by Compound 4-4-0s of two of these pigeon specials. On 27 May came Nos 1106 and 1111; these trains consisted of over 20 vans. On 28 May Alan noted that 3P No 716 was 'piloting on the SDJ'. With hindsight he wishes he had been more expansive in his remarks, for this was probably a unique occasion.

On Saturdays 30 July and 13 August he saw something that he never expected to see again — something which whisked him back in memory a whole decade — namely an MR 2-4-0 piloting a 2P 4-4-0. He was up to the neck in nostalgia! The 2-4-0 concerned was No 20157, a former Bath resident. After the August peak period during which he described traffic as being 'colossal', his diary stopped dead. Theological studies had taken over and he not longer had a permanent address in his beloved city. There is, however, one sad little epilogue written on Saturday 22 October when home for the week-end. It was 'Sheds and yards almost void of engines'.

Chapter 8

1939 and the Wartime Years

So dawned the fateful year 1939. No entries were made in his diary until 4 May when Crab No 2929 brought a crane into Bath from Rugby. The same exercise was followed ten days later, the motive power on that occasion being L&Y 0-6-0 No 12432. This was not the first of its class to visit Bath, as No 12140 had been shedded there for some months in 1933. On 20 May Jubilee No 5697 of Newton Heath headed a special to Bournemouth as far as Bath making what was probably the first visit for this class. Another first was the appearance of Compound No 1050 on the S&D on 5 August on a normal working; No 1065 had undergone trials there as far back as 1924! A paragraph in the local paper stated that Compounds were to be allocated definite duties on the S&D, but Alan is certain that very few ever made it. On 19 August was yet another first with Patriot No 5534 of Leeds drawing a pigeon special tender first! On 16 August 2P No 660 of Carnforth and 3P No 340 of Hellifield double-headed a train of empty coaches en route to Bournemouth. Peculiar things were happening! Terrible things were about to happen within the next two weeks.

On Tuesday 22 August, Alan went off for a week's stay at Tamworth. Two factors combined to make this venture something of a non-starter: the threat of a railway strike and the imminence of war. Because of the latter, the strike was called off. He went to London the following day and covered Willesden, Kentish Town, Plaistow and Devons Road. Willesden had 68 engines, quite a reasonable gathering for a Wednesday afternoon. Very little non-Standard stock was present and only 11 were LNWR items, though two of these were Claughton Nos 6004/17. Five Cauliflower 0-6-0s formed the largest batch of that company's engines. Kentish Town held 62 engines, but apart from a slightly higher proportion of Jubilees and Black Fives, there was virtually no change in the scene there from that which had obtained three years previously. Plaistow and Devons Road showed little variety, though at the latter, 3 North London 0-6-0Ts Nos 27510/2/28 made things a little more interesting. Alan had a great liking for this class. He saw his first, No 7513 at Acton in 1929 and the last in normal service, No 58862 in May 1951 at Rowsley, still with its original chimney. Perhaps the nicest touch to this rather sad occasion, (for he was not to return to London for almost seven years), was to see LNWR 0-6-2T Nos 6870/1 standing together outside Watford shed on his return to Tamworth. In view of the uncertain outlook, he curtailed the rest of his holiday. On 3 September 1939 the curtain came down upon the halcyon days and things were never to be quite the same again.

As far as Alan can remember, the first local sign of abnormality was a khaki-coloured GWR Dean Goods 0-6-0 running light through Bath bearing the insignia of the War Department. Most of the notes he was able to take during the war period were of a

LMS built 4-4-2T (to LTSR design) No 2153 at Plaistow, 24 August 1938.

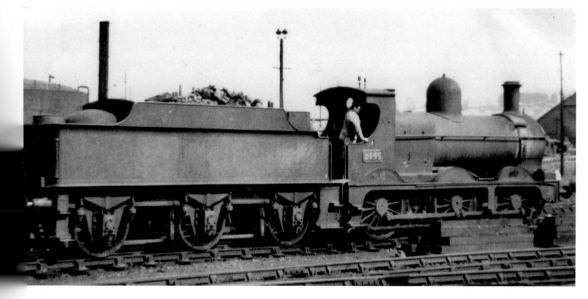

Dean Goods 0-6-0 No 2445 at Bristol, Bath Road, 25 July 1949.

local nature, though for a good deal of the time he was at theological college in the Midlands, with a chance to see periodically what moved on the main West Coast route at Lichfield (Trent Valley) and on the line from Birmingham to Lichfield City.

From the outbreak of hostilities to the end of 1939, the only entries he made for the Bath area concern the appearance of unusual motive power on the early afternoon freight formerly monopolised by Gloucester 3F 0-6-0s. Three Compound 4-4-0s, a Crab, a Black Five and a Jubilee on this turn were certainly a reminder that things were not quite what they used to be.

In the early part of 1940 Manningham sent two 0-4-4T Nos 1247 and 1353 to Bath, while 2-4-0 No 20008 visited the city again in March with the Engineer's Saloon. The appearance of 2F 0-6-0 No 3023 on GWR metals gave notice of the fact that peculiar happenings were in the offing. At the height of the Battle of Britain Stanier 8F 2-8-0 No 8014 was the first of its class to visit Bath, and early in 1941 Nos 8028/67/95 were shedded there. Stanier's 2-8-0s in the 82XX series were now appearing on the GWR. Many of this particular group were shipped to the Middle East and never returned. Alan caught sight of another MR 2F (No 3517) on GWR territory, this time at Bradford on Avon and gathered that Westbury shed was harbouring several of this class. The closing months of 1941 witnessed a mass immigration of SR 4-4-0s to Bath and the S&D section. All the S11s (Nos 395-404) were transferred together with T9 Nos 303/4/7/12. K10 Nos 388/9 arrived a little later.

Alan's travels to and from the Midlands began in September 1941. Birmingham bore the scars of enemy bombing, but the railway scene had not altered a great deal and it was re-assuring to see once again the familiar locomotives getting on with the job

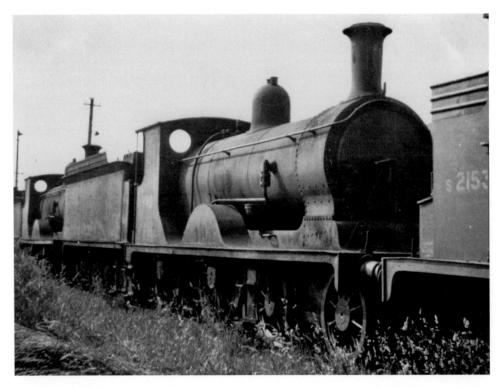

Condemned LSWR K10 4-4-0 No 380 at Eastleigh, 14 June 1949. The bunker of LBSCR E1 0-6-0T No S2153 is on the right.

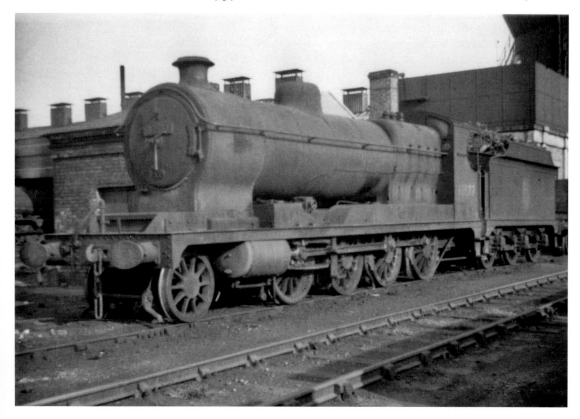

GCR O4/1 2-8-0 No 63577 at New England, 14 August 1954.

GWR ROD 2-8-0 No 3015, (the GWR purchased it from the Railway Operating Division post WW1; it was built to a GCR design) and 45XX No 4551 at Swindon, 19 March 1956.

despite the ravages of war. When he was free to do so, he would cycle out to Lichfield (Trent Valley) which bore a certain similarity to Tamworth, though there was not a great deal of traffic on the High Level line from Birmingham through Lichfield City to Burton on Trent. Passenger services were handled mostly by Fowler 2-6-2Ts from Walsall, (Nos 4, 11/7/8/9/, 45 and 69 being noted most frequently), by LNWR 2F 0-6-2Ts from Monument Lane, by an occasional 2P or 3P 4-4-0 and by a selection of Stanier 2-6-4Ts. Burton's 3F and 4F 0-6-0s handled the freight traffic along with LNWR 0-8-0s from Bescot or Walsall. Activity on the main line seemed little different from its pre-war setting, except, of course, that locomotives and rolling stock were beginning to look decidedly the worse for wear.

On his journey back to Bath in December 1941, he found it hard to take in what he saw running into Birmingham New Street — SR F1 4-4-0 No 1062. Further down the line were more surprises in store, for standing outside the GWR shed at Gloucester were SR Remembrance 4-6-0 No 2332 and LNER J25 0-6-0 No 2053. This was not all. SR K10 4-4-0 Nos 135/7 were at Yate and Westerleigh sidings respectively and he learned later that they were operating from Bristol, Barrow Road, in fact these two became regulars on the evening local freight into Bath.

On his return to the Midlands early in 1942, at Gloucester the GWR supplied the only real item of interest in the shape of LNER O4 2-8-0 No 6350. Between January and March he was able to observe a little more closely the movement around Lichfield City station and discovered a surprising variety of motive power there. Sixteen different classes were seen, including Royal Scot No 6138 and Jubilee No 5734 on freight workings. SR F1 class 4-4-0 No 1062 was a regular visitor. Down at Trent Valley life went on much the same as before, with the dear old Scots still pounding up and down, and Stafford Prince of Wales 4-6-0s recalling happier days. Nos 25674, 25725/98 took turn with each other and vied in asthmatic performance.

On 14 February he paid his first visit to Birmingham, Snow Hill. Large Prairie tanks dominated the scene and 2-4-0T No 3562 and LNER O4 No 6633 provided the only relief from the usual standard types. Passing Gloucester GWR shed on the way home, yet another LNER engine, this time J25 0-6-0 No 1964, adorned its precincts. During March 1942 the first sighting in Bath on the GWR of an LNER O4 2-8-0 (No 5393) was recorded and yet another first with SR T1 0-4-4T No 6 running in light from Mangotsfield.

3 July saw Alan at a rather different railway scene, namely Salisbury, where he had the opportunity to spend an hour or two on a platform seat. Due to wartime conditions no visit to the locomotive shed was possible but seeing that it disgorged most of its contents, sometimes in lines of four, not much would have been gained hereby. Alan recorded:

 4-6-0 types: 5 Lord Nelson, 17 King Arthur, 6 H15, 9 S15, 1 T14.
 2-6-0 types: 9 U.
 4-4-0 types: 17 T9, 4 D15,3 L12, 1 L11, 1 K10.
 0-4-2 type: 4 A12.
 0-6-0 types: 2 700, 1 0395.
 0-4-4T types 2 T1, 4 M7.
 0-6-0T type: 2 G6.

In addition to these there were several LBSCR types — B4 4-4-0 No 2074, I3 4-4-2T No 2087 as well as 4-4-2 Nos 2421/5. He also recorded his first encounter with the brain-child of Oliver Bulleid, for the Merchant Navy class had recently been launched

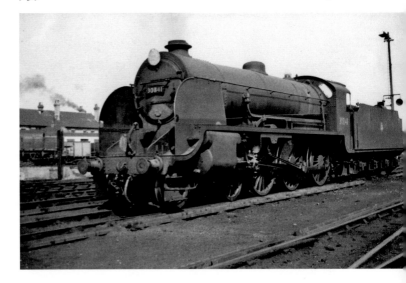

SR S15 4-6-0 No 30841 at
Salisbury, 23 April 1953.

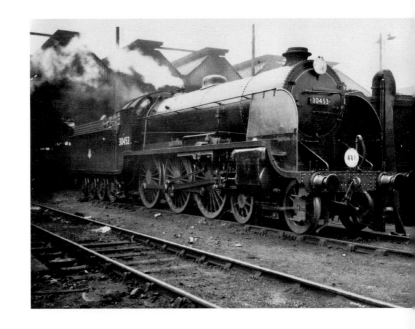

SR N15 4-6-0 No 30453
King Arthur at Salisbury,
25 May 1956.

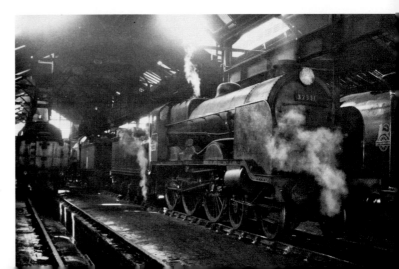

SR Remembrance 4-6-0
No 32331 *Beattie* inside
Salisbury shed, 25 May 1956.

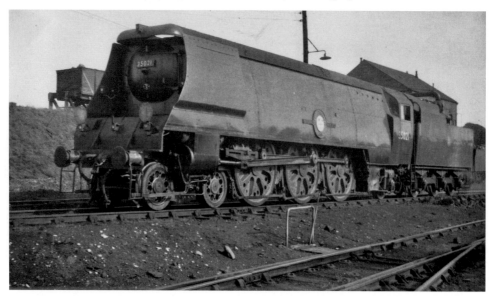

SR Merchant Navy 4-6-2 No 35021 *New Zealand Line* at Weymouth, 30 August 1953.

and five of them Nos 21C5 to 21C9, gave a new look and a new sound to the cathedral city. He disliked their appearance and also that of the light-weight version when it appeared, although in their later rebuilt form found them most attractive. Passing through Westbury on the return journey he spied MR 2F 0-6-0 No 3048. A few days later LNER 2-8-0 No 6309 passed through Bath, followed closely by her two sisters, GWR ROD class Nos 3013/20, and then SR 4-6-0 No 2332! It was becoming more and more a mixed-up railway world.

The main feature of 1943 was the arrival on the scene of the US Transportation Corps 2-8-0s. Alan had seen no announcement of their arrival, so when one sauntered through Bath GWR station on 15 July with a Down freight, it came as a complete surprise. Not that these machines required any announcement. They announced themselves with the incredible racket they made, for they seemed to have been designed to produce the maximum mechanical cacophony. No 1841 was his first sighting and during the year others were noted. Along with these immigrants came the new home-produced War Department 2-8-0s based on LMS 8F 2-8-0s. The first of these to appear on his horizon were Nos 7050/2/4 at Lichfield, Trent Valley, in the autumn of 1943. The GWR at Gloucester continued to embrace engines from foreign parts, SR 4-6-0 No 2331 being noted there in January and LNER J25 0-6-0 Nos 2040/76 in March.

Back at Bath he noticed that SR S11 4-4-0 No 400 enjoyed the luxury of a re-paint in April, (plain black for wartime economy), while cab numerals replaced the old attractive large ones on the tender. The new style of lettering adopted by the Southern was, he felt, an unfortunate choice. SR T1 0-4-4Ts had invaded the S&D's Highbridge branch, Nos 2 and 4 being seen at Glastonbury in July. The first Swindon-built Stanier 8F 2-8-0 No 8400 passed through Bath GWR station on 30 June, while towards the end of the year, several of this class from the Eastleigh production line were beginning to appear between Gloucester and Birmingham.

1944 was to prove itself a very significant year in more ways than one. In the first place it was the last complete year of WW2 and the last year before the return to something like normality on the railway front. For the first time he saw a 2-10-0:

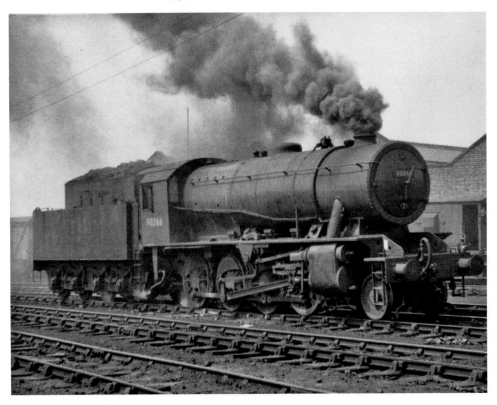

WD 2-8-0 No 90066 at Woodford Halse, 18 May 1961.

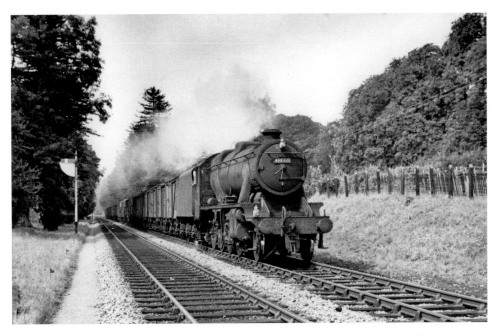

Class 8F 2-8-0 No 48669 (built by the SR at Brighton 1944) approaching Bradford on Avon with a Down freight, 15 August 1964.

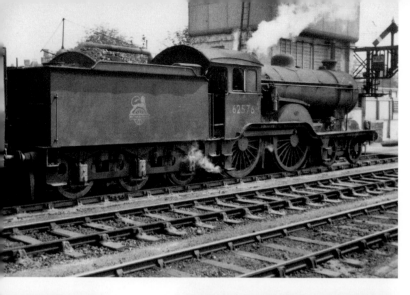

GER D16/3 4-4-0 No 62576 at Oxford 7 August 1957 having arrived on a special from Cambridge.

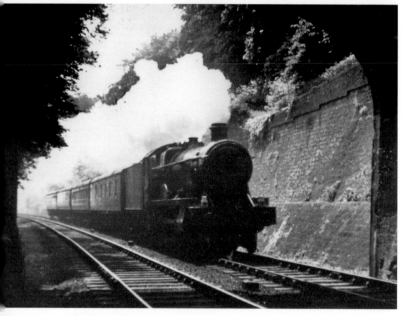

4-6-0 No 7927 *Willington Hall* about to enter Twerton Tunnel west of Bath with a Down express, 5 June 1951.

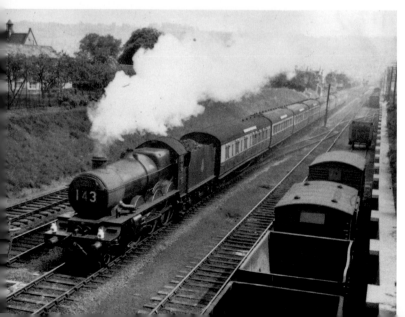

4-6-0 No 7025 *Sudeley Castle* approaches Oldfield Park with the Down Merchant Venturer, May 1953.

WD No 3738 standing dead outside Oxford LMS shed on 24 June, and a month later No 3692 was seen at Lichfield, Trent Valley. 1944 was to witness the unique sight of the appearance in Bath of LNER B12/3 4-6-os working ambulance trains in the period following D-Day. On 13 June No 8525 piloted by 2P No 696 arrived at the LMS station and No 8549 on 5 July. Bath GWR received No 8518 on 11 July, No 8516 on 14 July and 8509 on 19 July. No 8510 on 2 August was the last of these workings he recorded. SR T1 0-4-4T Nos 1 and 3 were seen running light between Bath and Mangotsfield in December and March respectively, but the wartime adventures of this class were almost at an end.

In the last week of June, Alan was in the Oxford area. It was pleasing to see GWR 0-4-2T No 1159 at Radley working the Abingdon branch. The LMS presence at Oxford was not without interest. Running in and out of the station on various occasions he noted 9 LNWR 0-8-os, Standard 0-8-0 No 9596, Prince of Wales Nos 25683 and 25805, 4 Stanier 2-6-4Ts, L&Y 0-6-0 No 12105 and MR class 2 4-4-0 No 510. On the GWR, MR 2F 0-6-0 Nos 3027, 3109 and 3372 were working. Another very pleasing sight, and one soon to be lost forever, was that of double-framed GWR 0-6-0 No 2378. At Banbury GWR station, LNER V2 Nos 4840/3 in surprisingly good external condition were down from Woodford Halse. On arrival in Bath he was given the news that during his absence WD 2-10-0 No 3737 had come into the city on the LMS, thus gaining the distinction of being the first of its class to do so.

In September 1944 Alan was appointed Assistant Curate of the Parish of Twerton, Bath. This was not a deliberate personal choice, although those who were aware of his railway interest may have been suspicious! The main Paddington to Bristol line ran the length of the parish and passed within a stone's throw of the parish church; the S&D came in on the south side, while the Midland line crossed into the parish over the Avon east of Weston station. The daughter Church of St Peter, where he became priest-in-charge in 1947, held Bath Junction and gasworks sidings within its territory, as well as Oldfield Park Halt on the GWR. He was very happy to have the railway and railway people within his pastoral care.

Towards the end of 1944 new Black Fives in the 48XX series were coming into service and appearing regularly on the war time train which had replaced the Pines Express. In March 1945 the arrival on the S&D's Highbridge branch of 0-4-4T Nos 1298, 1322/48 gave the SR T1s notice to quit. An ambulance train came into Bath LMS station on 31 March 1945 behind 2P 4-4-0 No 601 and Black Five No 4843. On VE Day 8 May 1945 he remembers standing in the churchyard of his parish church after the Thanksgiving Service. Two Swindon-built 8Fs Nos 8439/69 passed by on the GWR, while from a more distant point came the familiar calling-up whistle of a freight train engine to its banker, when about to ascend the gradient out of the city to Midford Tunnel. The war was over and what a magnificent contribution the railways had made to its successful outcome.

Chapter 9

The Early Post War Years

Alan's first thoughts in the post-war years was to get rid of his obsession with the LMS system and start to concentrate his efforts in other directions. Another consideration was that, since the war years had kept in service a large number of locomotives which would otherwise have been withdrawn, there was bound to be a vigorous scrapping and building programme in the offing. On 28 July 1945 he travelled to London to join a fellow enthusiast and planned to visit the two Southern strongholds of Battersea and Nine Elms, but Alan did not altogether bargain for the transport arrangements from Acton, where his friend lived. There he was presented with an apology for a bicycle and instructed to follow his friend, and the effort proved well worthwhile. Battersea had 75 locomotives on shed and Nine Elms 63 — a splendid gathering for a mid-week daytime. There was also an immense variety of classes — no less than 24 at Battersea and 25 at Nine Elms, making a total of 39 between the two. At Battersea, apart from King Arthurs of which there were 14, the most numerous classes were U1 2-6-0s, C 0-6-0s, E2 0-6-0Ts and H 0-4-4Ts. Among the more interesting were B1 4-4-0 Nos 1445/6/50/55 soon to be withdrawn; 2 I3 4-4-2T Nos 2089/90; No 1602, one of the two remaining T 0-6-0Ts and Crane Tank No 1302. Nine Elms had 5 T14 4-6-0s, 3 D1 0-4-2Ts, 2 B4X 4-4-0s and Kent & East Sussex Railway 0-8-0 No 949 *Hecate*. A third of the engines was made up of Merchant Navy, Lord Nelsons and King Arthurs.

During the early evening having more or less recovered from his unfamiliar exercise, he went over to Liverpool Street and in little more than an hour counted over 100 locomotives. A large percentage of these were of course N7 0-6-2Ts, but there was also a goodly number of B12/3 and Sandringham 4-6-0s, as well as Claud Hamilton 4-4-0s and F5 plus F6 2-4-2Ts. Equal to the intensity of the traffic, was the density of the smoke in which the station operated! Stopping off to look in at King's Cross on the way back to Paddington, Alan was able to pick out 3 GNR Atlantics among the usual gathering of N1 and N2 0-6-2Ts, as well as a certain No 8301 *Springbok* the first of a class that was to dominate the LNER territory until the demise of steam.

In mid-September 1945 Alan spent a couple of days with a college friend who was assistant curate at Pontardulais. This gave him the opportunity to see for the first time what went on across the mud and water from Weston super Mare. Although a good deal of the interest surrounding many of the extinct Welsh types had gone, there was still enough of the original Welsh ingredient left to make him feel that here was an area which warranted his full attention. The GWR had over 400 0-6-2Ts at the end of 1945 and nearly all of them were in South Wales and half of them were of Welsh extraction. Around 40 assorted 0-6-0 tanks remained and a dozen 0-4-0Ts of various shapes, sizes and origins. There was also a fair sprinkling of older GWR Pannier tanks which were

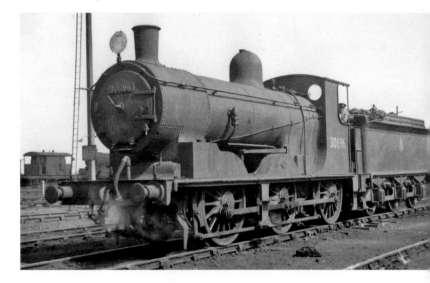

LSWR 700 class 0-6-0
No 30696 at Feltham,
4 September 1951.

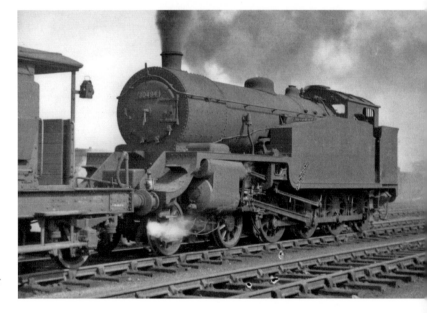

LSWR G16 4-8-0T No
30494 hump shunting
at Feltham, 4 September
1951.

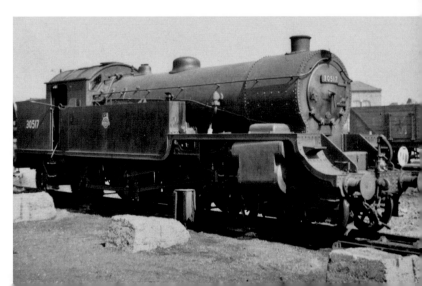

LSWR H16 4-6-2T No
30517 at Nine Elms,
3 September 1951.

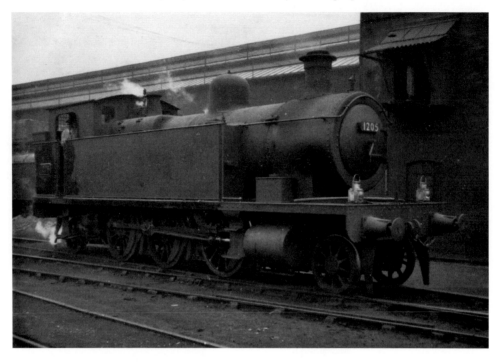

GEORGE DOW
PRESS RELATIONS OFFICER

TELEPHONE WHITWELL 76
EXTENSION 28

Letters to be addressed

THE PRESS RELATIONS OFFICER
LONDON & NORTH EASTERN RAILWAY
~~H Q 1 (VIA HITCHIN)~~

Dorset Square, London N.W.1

P 135/6 DC 24th April 1946

A. G. Newman Esq
95 Newbridge Road
Bath
Somerset

Dear Sir,

In reply to your letter of 22nd April,
owing to staff shortage and other difficulties
at the present time, we are having to limit
severely the number of public visits to our
locomotive depots and applications from railway
societies or educational bodies only can be
entertained.

We cannot, at the moment, allow single
individuals or groups of two or three persons to
visit our locomotive depots and I regret,
therefore, that I am unable to meet your request.

Yours faithfully,

Above: Alexandra Docks & Railway 2-6-2T No 1205 at Cardiff Canton, 8 September 1952.

Left: Letter from George Dow, Press Relations Officer and eminent railway historian, refusing Alan visits.

soon to be replaced. It was too much to expect that Alan could resist inspecting the LMS stake in South Wales. When he called, Swansea Victoria shed contained only 20 engines, but 3 were LNWR 0-8-4T Nos 7941/8/56, all in cared-for condition. Coal Tanks Nos 7741, 7807 and 27621, 2 0-8-0s and a single Cauliflower 0-6-0 made up an interesting LNWR collection.

A day or two later, Alan was in a somewhat different environment, that of Exeter and managed to get in a flying visit to Exmouth Junction. The new West Country class had just arrived and two, Nos 21C102/4 were on shed, where there were 50 engines all told.

His observations in the Bath area during the latter months of 1945 were chiefly concerned with the appearance of newly-built Black Fives on the Pines Express and the new Stanier 8Fs off the production line at Swindon. The arrival on 21 June of LMS 0-8-0 No 9596 from Wellingborough was a noteworthy event, as was No 9674 from Saltley which ran in light on 19 November.

The evening running-in turn from Swindon to Bristol passed Twerton parish church just before 6.30 Evensong. From the vestry window he could catch a glimpse of what was operating thereon, and on 9 August he was guilty of undignified behaviour before Divine Service when something with a new look came into view — an object with a copper-capped double chimney. The number was 1000. Mr Hawksworth was showing off the first of his wares, but Alan was not moved to write home about it.

1946 saw two visits to the London area. The first of these came at the beginning of May when his main intention was to see as much as possible of the LNER and SR systems. The former company was not issuing depot permits at this time, so he had to be content with selected observation points. Alan settled for Finsbury Park and Stratford, getting great joy out of the wealth of steam on parade at both those points. Two or three hours at Finsbury Park produced 132 locomotives, nearly half of which consisted of N1 and N2 0-6-2Ts and 28 J52 0-6-0STs. V2 2-6-2s were also around in goodly number. Eight Atlantics found their way into the proceedings, but they were all in sad condition and destined for early departure. GCR F2 2-4-2Ts were working the Alexandra Palace branch.

At Stratford some 143 engines were listed in about as many minutes. No less than 61 of these were N7 0-6-2Ts. Twenty two B12 4-6-0s, 13 B17s and a dozen Claud Hamilton 4-4-0s accounted for most of the remainder, while the appearance of a new star shining in the murk of Liverpool Street gave added interest to the scene. This was L1 2-6-4T No 9000 in green livery.

Alan joined his London friend in the afternoon of May Day 1946 and they made their way to Neasden where they gave themselves permission to enter the locomotive shed, an act not happily endorsed by the shedmaster. This was Alan's first visit to an LNER depot and although only 36 engines were present, it was a real delicacy. He was particularly pleased to see three ex-Metropolitan engines L2 2-6-4T No 6160 and M2 0-6-4T Nos 6154/6. The well-known 4-4-4Ts were gone, but he was fortunate enough to see two of them, Nos 7511/2 at Colwick in September the following year, just prior to withdrawal. Three B3 4-6-0s, 5 D11 4-4-0s and one D10 together with 3 J11 0-6-0s made up the tender engines on shed, while 4 L3 2-6-4Ts, then in their twilight years, seized his attention among the tanks of GCR origin. Four WD 2-8-0s were lined up in a siding. These had recently returned from the continent and three still bore their allocations on the cabside — 77091 (Le Havre), 77339 (Terneuzen) and 77427 (Le Mans).

To look at the Southern they went first to Hither Green, a small depot but with an attractive allocation. Since his first acquaintance with them in 1928, Wainwright's

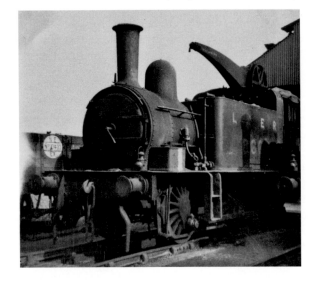

GER J92 0-6-0 Crane Tank No
8668 at Stratford, 21 May 1949.

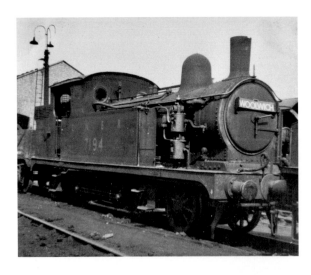

GER F5 2-4-2T No 7194 at
Stratford, 21 May 1949.

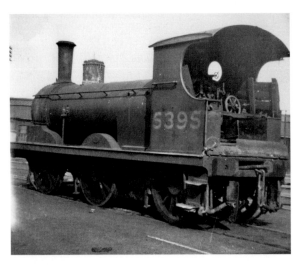

GER J15 0-6-0 No 5395 at
Stratford 21 May 1949 awaiting
scrapping.

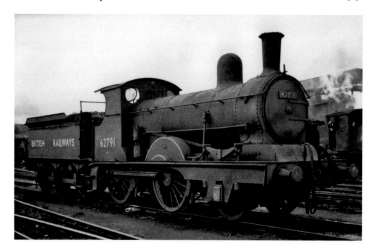

GER E4 2-4-0 No
62791 at Stratford
20 June 1952.

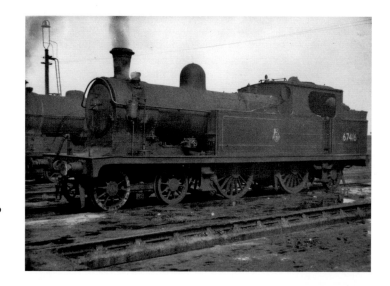

GCR C13 4-4-2T No
67416 at Neasden
4 September 1951.
It was used on the
Chesham branch.

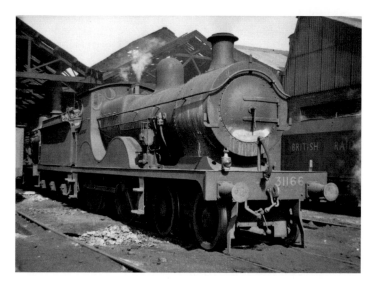

SECR E class 4-4-0 No
31166 at Bricklayers
Arms 3 September
1951. Unusually the
BR number is on the
buffer beam.

F1 4-4-0s had held a special place in his affections and four of them were on shed — Nos 1028/31, 110 and 1205 — waiting for the inevitable pronouncement about their future. The other ex-SECR engines were 11 C 0-6-0s, 3 0I 0-6-0s and one R1 0-4-4T. At the other end of the historical scale could be counted 6 W 2-6-4Ts and three of the large eight-coupled Z 0-8-0Ts. Bricklayers Arms, the next port of call, contained 67 locomotives. Half were 4-4-0s including 5 of Wainwright's B1 Nos 1217, 1453/4/5/9 which for Alan came a close second to the F1s. Five new Bulleid Light-weight Pacifics were an indication of the shape of things to come. Further WD 2-10-0s back from France were noted: Hither Green: Nos 77086 and 79203 (Boulogne), 77101 (Acheres) Bricklayers Arms: Nos 77094 and 79262 (Creil), 77311/21 (Le Havre) plus five others without allocations.

Alan's second visit to London was in somewhat different circumstances as he had just married. Wives have to be very patient and understanding with the likes of those who have caught the railway bug in early life and are pronounced incurable. Alan's choice was indeed a very blessed one. It was natural, of course, that she found cause to protest at things like getting her new white coat exposed to a baptism of smoke at Liverpool Street, or sitting knitting in the car for hours on end near the entrance to an engine shed — admittedly hardly ever set in the most scenic places. Passing Swindon 2-4-0T Nos 3568/81 were lined up for scrapping as were Aberdare No 2622, Dean Goods 0-6-0 Nos 2310/83, 2406 and Pannier Tanks Nos 2732/42/53/65. At Reading he was rewarded with a sight of Midland & South Western Junction Railway 2-4-0 No 1335 and SR M7 0-4-4T No 248 standing in the GWR shed, while the SR depot contained 10 engines including 2 F1 4-4-0 Nos 1183/8 and H16 4-6-2T No 519.

While in London he and his wife made a trip to Brighton where he saw plenty of steam and most of it LBSCR. 0-6-2Ts abounded, nearly all E4s. Several D3 0-4-4Ts were in action as was the one and only D3X No 2397 with the same wheel arrangement. The only standard stock there was a couple of Moguls and a new Light-weight Pacific.

In September 1946 Alan first made a tour of Eastleigh and was amazed at the variety of motive power. In the shed were 96 engines, 40 in the Works and 8 on the Dump, with no less than 41 different classes represented. Particularly worthy of mention were:

14 A12 0-4-2s, several of which had been lying idle for some time, No 646 having been withdrawn in 1939. T3 4-4-0 Nos 563/71, withdrawn in 1943. X6 4-4-0 No 657 (of 'Oh Mr Porter' fame),withdrawn in 1940 and No 666 withdrawn in 1943. H1 4-4-2 No 2040 withdrawn in 1944. The Dump contained 2 D1 0-4-2T Nos 2224 withdrawn in 1940 and 2233 in 1944; 2 Isle of Wight A1X 0-6-0T Nos W10 and W12 both withdrawn in 1936; an A1 0-6-0T in LBSCR livery; No 683; 2 0-6-0ST Nos 0332 and 3334 the latter withdrawn June 1933 and T1 0-4-4T No 17 withdrawn in 1945 and looking quite respectable in the surrounding company. In the Works Yard stood 0415 class 4-4-2T East Kent Railway No 5 soon to be returned to SR stock as No 3488, while I1X 4-4-2T No 2600 was there for cutting up. D1 0-4-2T No 2626 withdrawn in 1940 was undergoing the process of disintegration.

Eastleigh, Alan decided, was certainly worth visiting and in the years ahead, his Army Chaplain's duties at the nearby Netley Hospital provided the opportunity to go there frequently.

On a bright, but bitterly cold 24 January 1947 he made a return visit to Eastleigh. Exactly 100 engines were on shed, with the mixture much as before. The Works total had risen to 76 and included 4 WD 2-8-0s and 13 USA 0-6-0s soon to be taken into SR stock. A visit on 4 September found the running shed bursting at the seams with 140

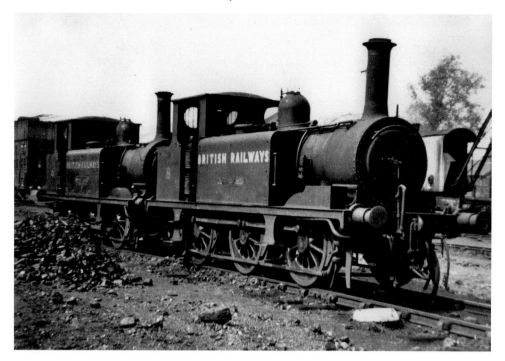

LBSCR A1X 0-6-0T No W8 (formerly *Freshwater*) and W13 (formerly *Carisbrooke*), at Eastleigh 14 June 1949. When transferred to the mainland they became Nos 32646 and 32677.

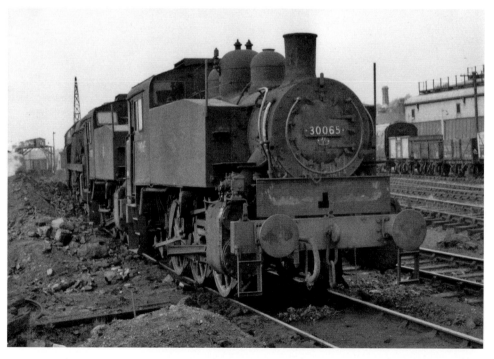

Ex-US Army Transportation Corps 0-6-0T, purchased by the SR in 1946 and fitted with a modified cab and bunker. No 30065 is seen here at Eastleigh, 5 November 1962, ousted from work at Southampton Docks by diesel shunters.

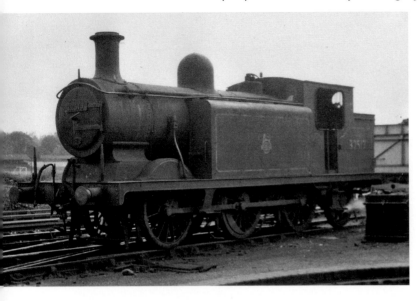

LBSCR E4 0-6-2T No
32517 at Tunbridge
Wells West, 25 August
1958.

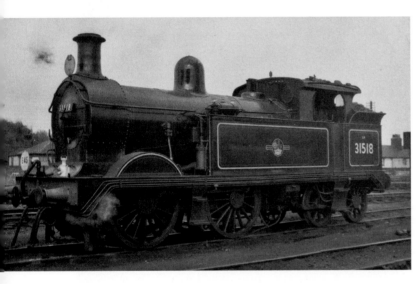

SECR H class 0-4-4T No
31518 at Tonbridge in
ex-works condition, 25
August 1958. Above and
in front of the near side
tank is the apparatus for
working the regulator
from the control
vestibule of a push-pull
unit.

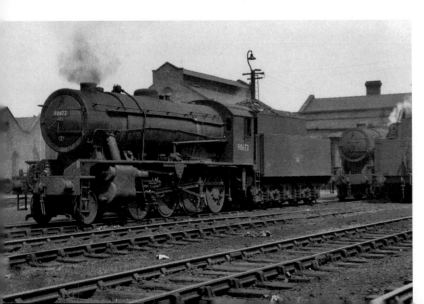

WD 2-8-0 No 90672 at
Woodford Halse 18 May
1961. Behind is a sister
engine.

engines present. 18 A12 0-4-2s were in residence, but by the end of the year only 4 of this class remained in service.

At the end of May 1947 Alan travelled from King's Cross to Peterborough, merely going for the ride and with no thoughts of attempting to assail the bastion of New England shed. However Peterborough was so obviously a joy to behold that he requested an interview with the shedmaster. He was much younger than expected and most approachable. 104 engines were present with 22 different types making that number. Topping the list were 17 Green Arrow 2-6-2s, 15 K3 2-6-0s and 14 WD 2-8-0s, some of which had been taken into LNER stock and numbered in the 3XXX series. GNR 0-6-0s were well represented with 11 J6s, 6 J4s (4 ex-Midland & Great Northern) and 3 J3s. There was the same excellent variety of motive power to be observed in and around Peterborough North, 17 different classes ranging from Y4 Sentinels to A4 Pacifics in a list of 40 locomotives.

A complete change of scene was enjoyed the following day with a visit to Tonbridge and Tunbridge Wells. The former was still solidly SECR territory. C and O1 0-6-0s formed the largest contingent, while all existing 0-4-4T types and most of the 4-4-0 classes appeared. Three D3 0-4-4T headed a small LBSCR ingredient and one of these, No 2370, hauled his train to Tunbridge Wells. Here he found 15 engines, all LBSCR of 4-4-2T, 0-6-2T, 2-6-4T, 0-4-4T and 0-4-2T classes.

On 30 May he made a return visit to Neasden, his appetite having been well and truly whetted on his first call a year before. Evidently he chose a good time of day for 56 engines were on shed, 34 of which were GCR. 15 of these were A5 4-6-2Ts, 6 N5 0-6-2Ts, 5 L3 2-6-4Ts and a couple of D11 4-4-0s. B3 No 1495 and B18 No 1480 were the only 4-6-0s present. Several GNR 0-6-2Ts had joined the Neasden stud.

In late summer he visited Woodford Halse, a depot in a most delightful setting surrounded by fields. The depot contained 48 engines in a creditably clean condition as was the shed itself. Over half the locomotive strength consisted of 2-8-0s: 19 WD and

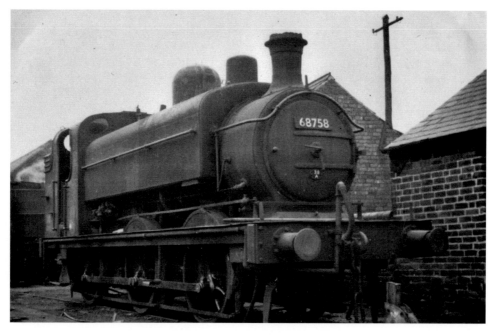

GNR J52 0-6-0ST No 68758 at Colwich, 11 September 1955.

6 O4s. There were 3 J50 0-6-0Ts, 5 J5s and the same number of J11s and 2 K3 2-6-0s; the 6 B1s had ousted the GCR 4-6-0s and Atlantics once allocated there. A rather sad looking B3 No 1498 was the sole reminder of the former order of things.

A few days, on 7 September, Alan called in at Colwick and was given a marvellous feast: 147 locomotives and 24 different types. Ex-GNR stock numbered 63. Apart from 24 O4 2-8-0s, GCR representation was very small — just 11 including a solitary Atlantic, 3 4-6-0s and a 4-4-0. The two remaining Metropolitan Railway 4-4-4Ts were, arguably, the most interesting items there.

1947 was the year he began his onslaught on South Wales. During August and September he visited Newport (Pill and Ebbw), Pontypool Road, Cardiff (East Dock and Cathays), Barry and Radyr. Ebbw Junction with 76 on shed was completely devoid of any Welsh element, but the little depot at Pill with 26, had 4 Brecon & Merthyr 0-6-2Ts; 1 Rhymney 0-6-2T and Alexandra Docks 0-6-0T No 666. Pontypool Road had 56, but nothing exceptional except 2 Bulldogs (Nos 3406/53) and a Taff Vale 0-6-2T. Cardiff East Dock had a good Rhymney presence. Out of the 26 engines there, 10 were of that extraction and 3 others were Taff Vale. Cathays offered a good mixture of Rhymney and Taff Vale tank engines amongst the 34 there. Barry came up with as many as 50 engines in and around the shed of which 46 were 0-6-2Ts (Rhymney, Taff Vale and 56XX types). The 4 odd men out were 0-6-0PTs Nos 2000, 6745/7 plus Barry 0-6-0T No 783. Radyr offered 7 Rhymney 0-6-2Ts, 4 Taff Vale 0-6-2Ts, a Barry 0-6-2T, 2-4-0T Nos 3597/9, 2 56XX 0-6-2Ts and 2 Panniers. Cardiff General was alive with traffic. The only portent of things to come was a couple of diesel railcars (Nos 2 and 4) which disgraced the proceedings from time to time.

September 1947 saw him back at Nottingham; the total of 126 engines he saw there comprised:

28 4F 0-6-0s; 20 8F 2-8-0s, 14 2P 4-4-0s, 7 LTSR 4-4-2Ts, 6 Black Fives; 6 Compounds; 4 Crabs; 3 each of: Jubilees, Stanier 2-6-2T, MR 0-4-4T and L&Y 0-6-0; 2 each of 3P 4-4-0s and MR 0-6-0T. 1 each of Stanier 2-6-4T; Fowler 2-6-4T and Standard 0-8-0.

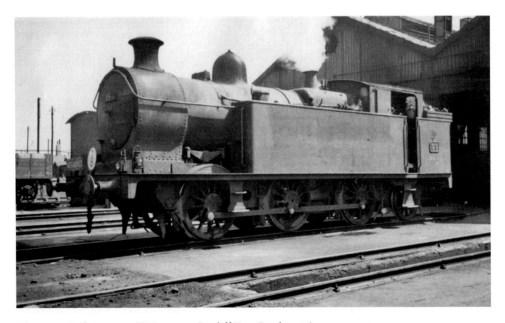

Rhymney Railway 0-6-2T No 35 at Cardiff East Dock, 16 August 1951.

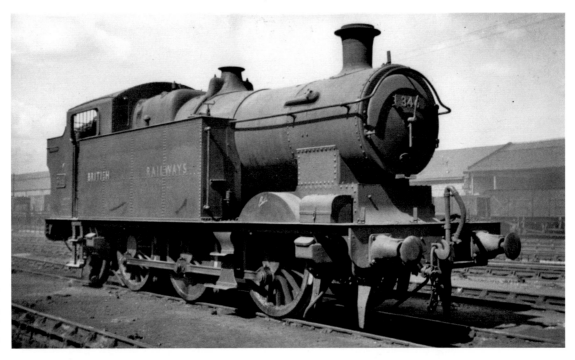

Taff Vale Railway 0-6-2T No 346 at Cardiff Cathays, 16 August 1951.

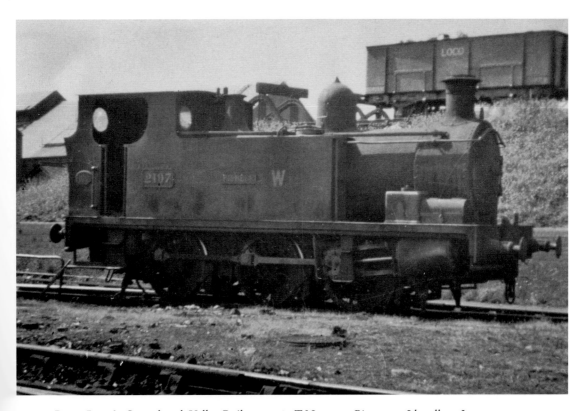

Burry Port & Gwendreath Valley Railway 0-6-0T No 2197 *Pioneer* at Llanelly, 1 June 1950.

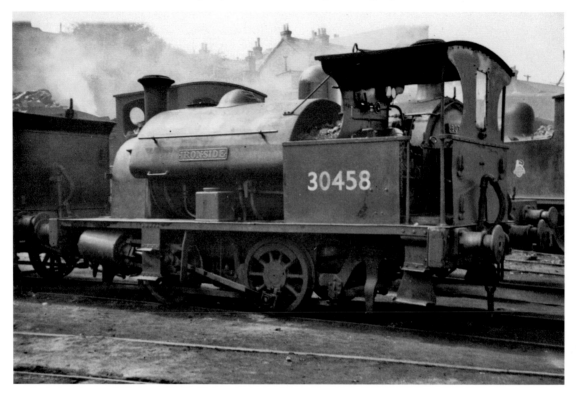

LSWR 0458 class 0-4-0ST No 30458 *Ironside* at Guildford, 22 June 1952.

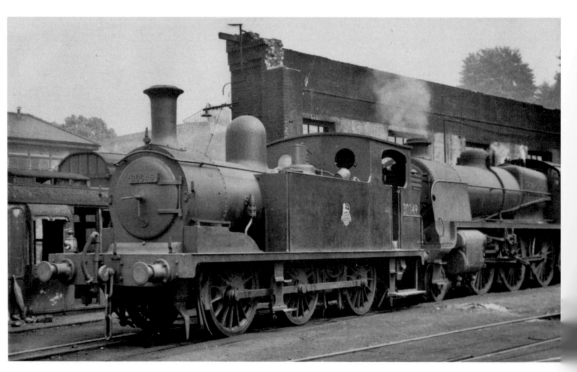

LSWR G6 0-6-0T No 30349 at Guildford, 19 June 1952.

Toton offered 130 engines comprising:

> 44 8Fs; 29 2F and 3F 0-6-0s; 23 Garratts; 16 4F 0-6-0s; 7 diesel 0-6-0s; 6 Jinties and 1 MR 0-4-0T.

The next day he toured Crewe Works. With a grand total of 148 locomotives on site this was by far the best of all his visits there. Nearly half of them were ex-LNWR — 13 0-8-0s; 10 Coal Tanks, 11 Coal Engines and 2-4-2Ts; 6 Cauliflowers; 3 2P 0-6-2Ts; 2 Prince of Wales and one each of Precursor 4-4-0, 0-4-2T; 0-6-0ST, 0-8-4T and 0-8-2T. In addition to these there were 3 Works' Shunters and 2-4-0 *Hardwicke*, the latter restored to her LNWR condition. *Lion* was outside the Erecting Shop standing with Pacific No 6210 *Lady Patricia* — a century of railway history between them.

A few weeks later he was able to enjoy a complete change of railway scenery as a result of being invited to officiate at a cousin's wedding in Maidstone. Guildford shed was somewhat unique in that it was an open roundhouse and Horsham of similar design. Guildford was full of interest being the meeting place of all three sections of the SR. There he found 35 engines, mostly of LSWR origin. There were a couple of LBSCR E4 0-6-2Ts in attendance as well as Plymouth, Devonport & South Western Junction Railway 0-6-0T No 756 and 5 Q1 0-6-0s. Ashford had 54 engines on shed and exhibited 22 classes. Three King Arthurs, a couple of 2-6-0s, a West Country and a WD 2-8-0 were the only post-grouping types visible, and apart from 4 LBSCR engines, all the rest were of SECR origin. Gillingham, with only 25 on shed, displayed 12 different classes all ex-SECR.

In October 1947 Swindon at last drew aside the iron curtain. The first post-war Open Day came on Wednesday 2nd, and the approaches to the Works were crowded to such an extent that presented something of a problem to the authorities. Alan was fortunate enough to be assigned to one of the smaller groups. The Dump was out of bounds, but with quiet persuasion and unashamed bribing, his guide took him there as well as to the running shed. The Works contained a total of 141 locomotives. Making their entry into service were new Halls Nos 6971-4. The running shed held 57 engines.

In the Bristol-Bath area 1947 started interestingly with the arrival at Bath LMS on 2 January of Stanier 0-4-4T No 1902. During the next few months three of her sisters joined her, No 1903 in March, 1904 in May and 1900 in June. These four engines handled local passenger turns until October 1949 when they were ousted by the allocation of four new 2-6-2Ts to Bath, Nos 41240-3, one of which (No 41241) later found her way to the world of preservation. On 7 February Alan noted the first arrival at Bath LMS of a Swindon-built 8F, No 8405. On the GWR, most of his diary entries were concerned with the appearance of oil-burning engines, Halls in the 39XX series and a Castle or two, the latter retaining their original numbers. At St Philip's Marsh, Bristol, ex-Weston, Clevedon & Portishead Light Railway Stroudley Terriers Nos 5 and 6 could be seen on shed together looking like fish out of water.

A moment or two after midnight on 1 January 1948 the sound of many locomotive whistles on the night air heralded the Nationalisation of the railways of Britain, however when daylight came nothing looked different. Within a very short time the erasure mania was entered, when the insignia of the former companies was removed from every possible notice or piece of equipment. Alan has in his possession a works plate from Stanier 8F No 48732. It should read 'LMS. Built 1943 SR' but the letters LMS have been ground away — an untidy and quite unnecessary exercise. It is a wonder that SR survived the childish antics of the iconoclasts.

In 1948 Alan determined upon a policy to make the acquaintance of every surviving class of locomotive in Britain. In July he went to Cambridge to see a Great Eastern E4

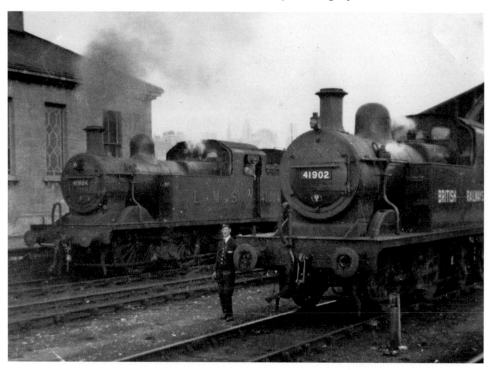

Stanier 2P 0-4-4T No 41904 and No 41902 at Bath April 1949. No 41904 has been re-numbered in LMS style, while No 41902 has the 'British Railways' lettering on the tank.

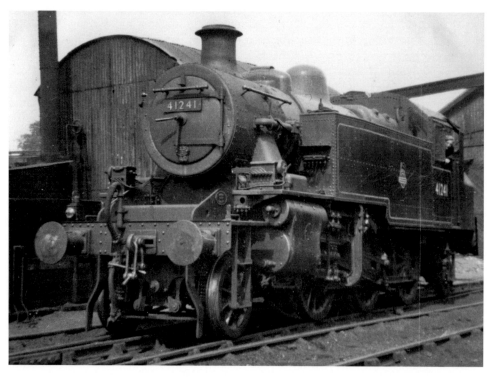

Class 2 2-6-2T No 41241 at Bath in July 1950 shortly after being delivered new from the works.

§PS (⁶⁄₄₉) **THE RAILWAY EXECUTIVE** (1387 V/MP 1)
SOUTHERN REGION

Reference HO/V/300 MOTIVE POWER SUPERINTENDENT,
Mr A.G.Newman, WATERLOO STATION, S.E. 1.
Rose Cottage,
High Street,
Twerton-on-Avon, 31st August 1949
Bath.
 DEAR SIR,

In accordance with your request, I have been pleased to arrange for your visit to the undermentioned Motive Power Depot on the date shown below.

Visits should be concluded by 5.0 p.m., unless a later time is specially sanctioned.

This permission is given subject to the presentation, immediately on your arrival at the Motive Power Depot, of this permit together with the return half of Southern Region railway ticket (as indicated below) for each person covered by the permit, it being understood that no person under 16 years of age can visit a Motive Power Depot unless accompanied by an adult.

Each visitor must also produce his National Registration Identity Card as proof of British nationality.

Photographs may be taken for private collection only.

No luggage (except cameras) must be brought on Motive Power Shed premises.

Motive Power Depot to be visited	Date	Number of persons	Rail tickets to be presented
FRATTON	1st September 1949.	One	Yes

Acceptance of this permission will constitute an agreement by or on behalf of each visitor that he / she / they will (jointly and severally) be responsible for and release and indemnify the Railway Executive and the British Transport Commission and any other body or person owning working or using the said premises and their servants and agents and any other person whomsoever occupying being upon or using such premises from and against all actions, claims, losses, costs and expenses by reason of any personal injury (whether fatal or otherwise) delay, or detention, or loss of or damage to property, however caused (whether by neglect or otherwise) and by whomsoever brought, made or suffered occurring in consequence of or in connection with the granting of such privilege.

The permit is not transferable and must be given up before leaving the Shed premises.

Yours faithfully,

For T. E. CHRIMES

Permit to visit Fratton Depot, 31 August 1949.

THE RAILWAY EXECUTIVE
~~SOUTHERN RAILWAY~~ *M 1093/48.*

C. M. E. ~~SOUTHERN REGION~~
DEPARTMENT. (509A / 9/44.)

No. **3033**

Waterlow & Sons Limited, London and Dunstable.

Permit Mr *Revd. A J Newman*

to enter the ~~Company's~~ Railway Executive's premises at *Eastleigh*

for the purpose of *viewing locomotive works*

on *14th June 49*

NOTE.—This permit is issued on the strict understanding that no liability whatever rests with the Railway Company in connection with any injury or loss sustained by the holder(s) while on its premises and the use thereof implies the acceptance by the user or users of these conditions.

O. V. BULLEID.

Date 10 JUN 1949 19

Permit to visit Eastleigh Works, 10 June 1949.

2-4-0 and in September to cast his eyes on the hitherto unseen North Eastern types. A visit to Crewe, Derby and London and the south east became an annual affair, while Swindon and Eastleigh received a call two or three times a year and hardly a stone was left unturned in South Wales.

On 17 July 1950 with a London colleague, he joined The Capitals Limited from King's Cross to Edinburgh. This was a non-stop run behind Gresley A4 No 60026 *Miles Beevor*. By that date a fair slice of the former Scottish locomotive stock had of course gone, but there was still a substantial number of Caledonian and North British engines surviving, especially the six-coupled tender and tank types. Some 300 Caledonian and about the same number of North British 0-6-0s survived, whilst 0-6-0Ts of Scottish origin numbered around 250. One or two classes were still intact, such as the North British C15/16 4-4-2Ts and N15 0-6-2Ts, while there were still over 100 Caledonian 0-4-4Ts very much alive and kicking, as well as a fair number of 4-4-0s. The delightful Great North of Scotland Railway D40/41 4-4-0s held their place at Aberdeen. Former Highland Railway stock was down to 5 4-4-0s and 4 0-6-0s plus the preserved Jones Goods at St Rollux Works. During the course of 3 days Alan was able to record 1,200 locomotives.

In May 1951 and in July 1952 he partook of outings organised by the London Branch of the Railway Correspondence & Travel Society which were incredible feats of endurance. On both occasions they set off from Euston for Crewe shortly after midnight, arriving there at 5.00 a.m. An early morning jaunt around North Shed produced a tremendous appetite, well-satisfied with an excellent breakfast in

the station restaurant which opened its doors at 7.30. On 18 May after a tour of the Works, (150 locomotives seen, Britannias coming off the production line), they made their way through Stoke on Trent to Derby where they saw 107 engines in the Works, (including LNER J39s passing through the shops); then on to Nottingham, Mexborough, Doncaster (134 on shed) and Hull. Just 16 short of 1,000 locomotives seen in one day.

The following day they started at York (134 on shed) and went on to Darlington, (62 in the Works); West Auckland, Consett, Tyne Dock, Borough Gardens, Percy Main, North and South Blyth and Goole, finishing the day with 460 on record. On the third day they began with Blaydon (63 on shed), Heaton (110 on shed) and Gateshead (81), before threading their way homeward through Sunderland, West Hartlepool, Haverton Hill, Middlesborough Newport (93), Darlington (112), Starbeck, Rowsley, Buxton and Macclesfield. This exercise produced another 775 locomotives for the record, with a total for the three days of no less than 2,218. The similar effort in July 1952 was a two-day affair covering 25 sheds in the northern part of England. Alan counted exactly 1,200 locomotives — a rate of nearly 100 per hour!

The local scene at Bath provided a variety of motive power, brought about in no small way due to the fact that Bath, London Midland Region (22C) soon became part of the Southern Region (71G) and later still part of the Western Region (82F). The appearance of SR locomotives was confined to the light-weight Pacifics, though two Moguls, U No 31621 and U1 No 31906 were tried on the S&D in March 1954 and found wanting. Alan found it hard to describe his feelings when the WR brought a 55XX Prairie tank in on a Bristol-Bath turn that used to be the undisputed preserve of a Midland 0-4-4T, or when he saw Pannier tank No 3742 taking over shunting at the Midland Goods Yard. Of the GWR 4-6-0 classes, Halls, Granges and Manors made an occasional appearance at the ex-LMS shed as did GWR 2-8-0s. He felt that Great Western engines were trespassers; they looked wrong and sounded wrong on a stage which had never been set for them. It was the same at Bristol Barrow Road which in

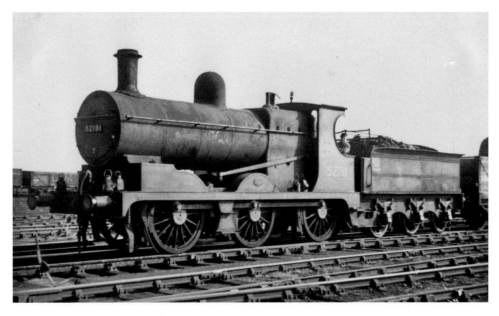

L&Y 0-6-0 No 52191 at Goole, 18 May 1951.

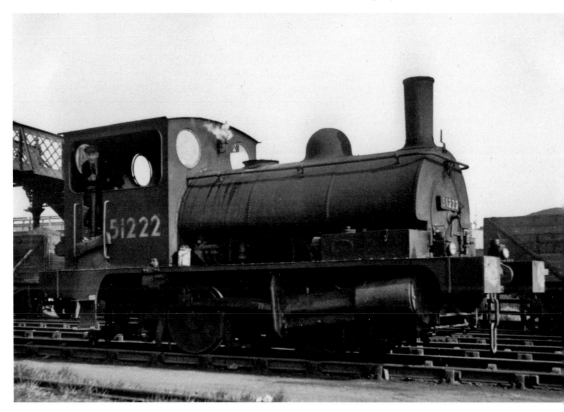

Dumb-buffered L&Y 0-4-0ST No 51222 at Goole, 18 May 1951.

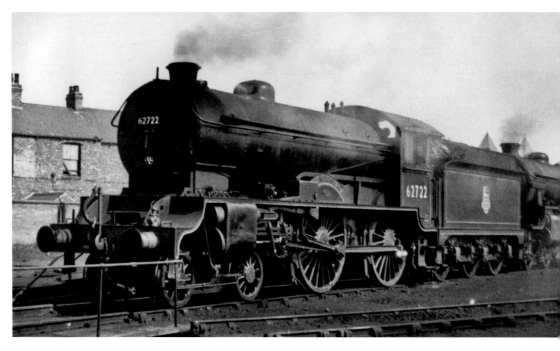

LNER D49/1 4-4-0 No 62722 *Huntingdonshire* at Hull Botanic Gardens, 18 May 1951.

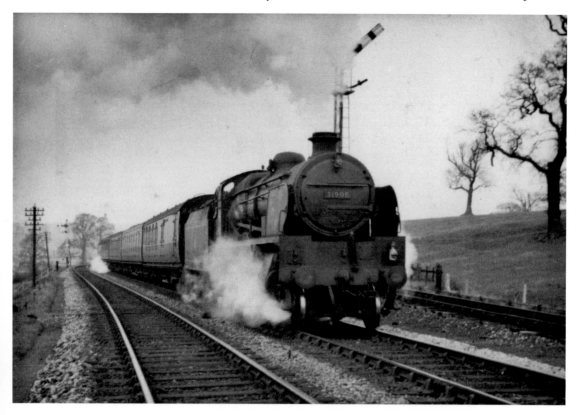

SR U1 2-6-0 No 31906 on trial working the 4.25 p.m. Bath to Bournemouth West, 8 March 1954.

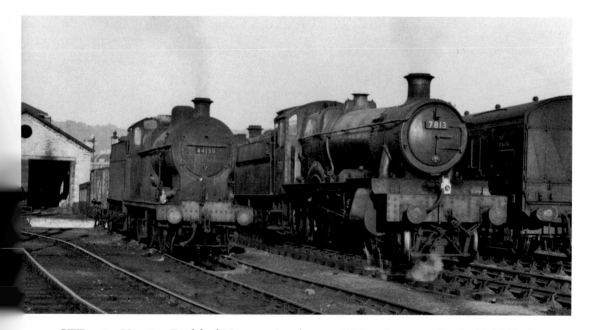

GWR 4-6-0 No 7813 *Freshford Manor*, an interloper on MR territory, standing beside LMS 4F 0-6-0 No 44139 at Bath, Green Park 10 May 1961. Both engines are far from home, the Manor from Tyseley and the 4F from Nottingham.

its last days became the concentration point of the remaining steam in that city. The GWR engines there, in filthier condition than the rest, with nameplates and number-plates removed and numbers scribbled in white on their cabsides, gave a depressing air to the place.

When the end came at Bath Green Park, could they not at least have used a couple of 9F 2-10-0s to haul away the lines of engines for premature slaughter? The grubby Peak diesel-electric and Hymek diesel-hydraulic assigned to this task, hardly formed the happiest of endings to his 53 years of observation of the line. 'Sic transit gloria mundi' (So passes away earthly glory) — how well does the Latin express it.

Peak class diesel-electric D15 hauls BR Class 5 4-6-0 No 73001; Class 4 2-6-4T No 80043; LMS designed 8F 2-8-0 No 48444, but built by the GWR and BR 9F 2-10-0 No 92243, out of Bath to the scrap yard.

Chapter 10

He Discovers the Delights of Industrial Railways

The end of main line steam at Bath gave Alan an opportunity to concentrate more on a different aspect of railways. On 4 August 1953 he decided to join a tour of Avonmouth Docks. No less than 13 of the locomotives out of the 21 on strength of the Port of Bristol Authority were dated between 1900 and 1918. What a find! This sudden conversion of interest was very much akin to that which took place when he met with that Midland Jumbo back in May 1927. Here was a new and quite exciting railway world and with it the prospect of encountering the unknown. The presence at Avonmouth of 4 brand-new diesels was an obvious warning of the shape of things to come, so the element of urgency was there at the beginning. Alan had, of course, seen dozens of small engines on industrial sites in his travels, but hitherto had given them scant attention, except perhaps for Peckett No 1267 of 1912 which shunted at Bath Gas Works and its second engine Avonside No 1978 which arrived in 1928.

His new-found enthusiasm led him first of all to search out what lived and moved and had its being in his immediate area. The two Bath Gas Works engines were still alive and well and he discovered a very nice Peckett 0-6-0ST *Lord Salisbury* at Norton Hill Colliery, just returned from a complete overhaul at Peckett's Works. The nearby Kilmersdon Colliery had a Peckett 0-4-0ST of 1929. This latter engine was the last working steam locomotive to survive in Somerset. The warm-hearted Ernie Loader extended to Alan an open invitation to ride the footplate with him and he took up this offer on several occasions. On the last occasion in March 1973 they traversed a lot of old track that had been out of use of years and at one place came to rest a foot or two away from a sheer drop of 20 feet into a brook.

Quarries in the Frome area had steam locomotives, but nearly all of them were fairly new Sentinels with vertical boilers set in their cabs. Bristol's gas works possessed a few steam locomotives as did some factories. Alan went along to Peckett's Works at Bristol, but was politely told that there was nothing to see, despite the fact that 0-6-0ST *Nancy*, a very nice specimen of 1905, was in steam in the yard outside. Alan rarely got a refusal from anyone, in fact most firms were extremely helpful and it was somewhat ironic that the first of the few which did give refusal should come from Peckett's.

Alan found that uncovering industrial steam almost on his doorstep was great fun. The whole country now lay before him for exploration, but since it was necessary to know where to look for those gems, some kind of guidance was essential. This came in the form of excellent regional booklets on industrial locomotives published by the Birmingham Locomotive Society. It was clear from their contents that a wealth of old engines had gone to breakers' yards, but that there still remained enough to keep him happy for years to come.

Port of Bristol Authority 0-6-0ST *Strathcona*, Peckett No 1243 of 1910, at Avonmouth Docks, 4 August 1953.

0-6-0ST *Lord Salisbury*, Peckett No 1041 of 1906, at Norton Hill Colliery, 8 September 1953 shortly after overhaul.

Roads Reconstruction 0-4-0ST *Medway,* Andrew Barclay No 969 of 1903, at Whatley Quarry, Frome, 20 July 1954. It is fitted with a coupling hook, but no 3-link coupling.

Roads Reconstruction Sentinel 0-4-0 No 6090 of 1923 at Hapsford Quarry, Frome, 20 July 1954. This engine was displayed at the Wembley Exhibition, 1924. Although Alan saw it there in 1924, it did not register, as *Flying Scotsman,* and *Caerphilly Castle* were much more memorable.

Left: Some industrial locomotives could be seen in rural surroundings: Kettering Furnaces No 2, Black, Hawthorn 0-4-0ST No 501 of 1879, seen here 16 March 1962.

Below: Industrial engines were not always small: Beyer-Garratt 0-4-4-0 *William Francis* at Baddesley Colliery, 22 May 1963, No 6841 of 1937.

A turn of events about this time was to prove most favourable, for two fellow members of the Bath Railway Society also declared their interest in industrial railways and together they formed a trinity. Ivo Peters, of S&D photographic fame, provided the transport; Norman Lockett took on the role of navigator and Alan was appointed correspondent, it being thought that letters written on vicarage notepaper would be found more acceptable to firms. It certainly worked as very few requests were turned down and large organisations such as the National Coal Board, the Central Electricity Generating Board and Stewarts & Lloyds, to mention only a few with which he had considerable dealings, could not have been more helpful.

It was in the slate quarries of North Wales that they made their first survey of an extensive narrow gauge system and became acquainted with, and captivated by those delightful little Hunslet 0-4-0STs which ran round the galleries like beetles. Then for several years they concentrated their attention on the ironstone railways busily working in Oxfordshire, Northamptonshire, Rutland, Leicestershire and South Lincolnshire. The variety of design and age range of the locomotive stock they saw was quite remarkable. For instance, in the nineteen-sixties Kettering Furnaces had two Black Hawthorn 0-4-0STs, No 2 built in 1879 and No 3 in 1885 still going strong, while Corby's 0-6-0ST No 64 arrived from Robert Stephenson & Hawthorn as late as 1958. In the early sixties there was still a substantial steam element in the steel works and collieries of South Wales, the Victoria Steel Works, Ebbw Vale having a stud of 24. Some ex-main line locomotives were to be found. After a short and undistinguished career with BR, Swindon-built 0-6-0PT Nos 1501/2/9 were to be seen at Coventry in plain red livery.

Measham Colliery was a favourite port of call. The manager there was a steam enthusiast and one of his charges was a Robert Stephenson Hawthorn 0-6-0ST of 1946 *Progress*. The NCB blue was tastefully lined out in maroon and kept in pristine condition. They were given unprecedented freedom to photograph it and they gained the impression that someone was reluctant to have it used for normal purposes.

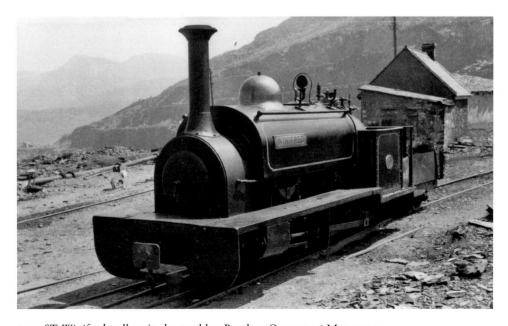

0-4-0ST *Winifred* well up in the world at Penrhyn Quarry, 26 May 1959.

Manning Wardle 0-4-0ST No 345 of 1871 at Pitsford Ironstone Railway, 9 May 1960.

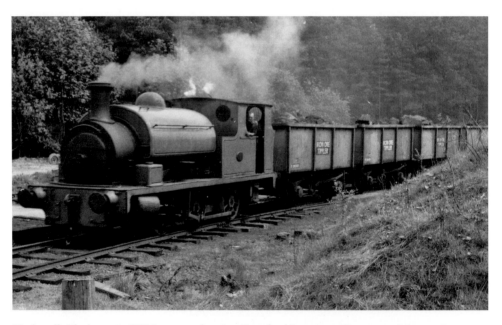

Hudswell, Clarke 0-6-0ST No 1579 of 926 at Cranford Ironstone Quarry, 10 May 1960.

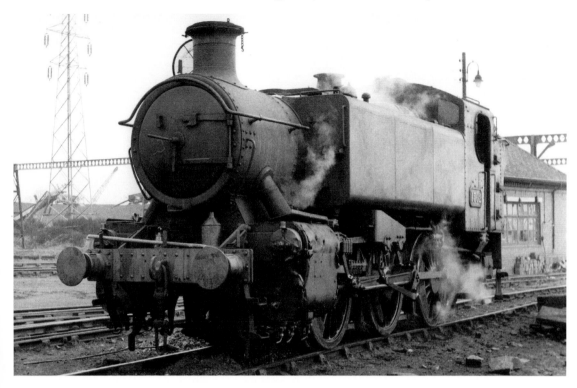

Ex-BR 0-6-0PT No 1502 at the NCB, Coventry, 25 April 1963.

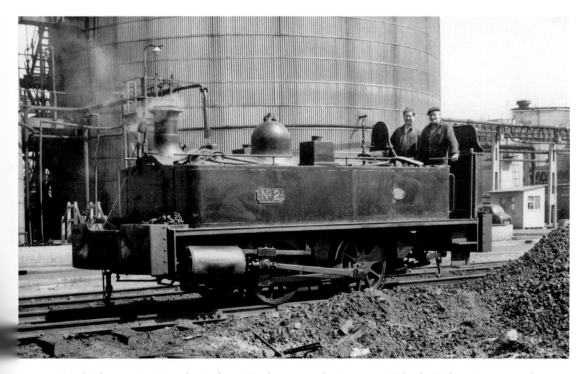

North Thames Gas Board's Beckton Works open-cab No 2 0-4-0T, built Neilson No 4445 of 1892. Viewed on 27 April 1964.

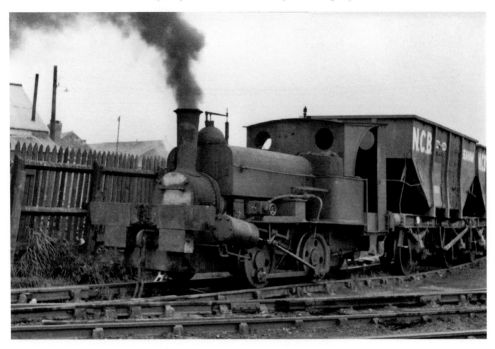

Lewin 0-4-0ST of 1863 at Seaham Harbour, 13 June 1967.

The NCB in Lancashire had its headquarters at Walkden. Alan's main interest here centred on ex-Staffordshire Railway 0-6-2Ts, formerly LMS Nos 2257/62/64/71. They had been sold out of stock back in the thirties, and No 2271 had been restored to North Staffordshire livery as No 2 before Alan and his friends made their first visit. In the later sixties when BR steam had almost evaporated, the trio found their way to the NCB areas of Yorkshire and Durham and found industrial steam very much alive. The systems of the various electricity generating stations and gas works came to their attention. Beckton Gas Works owned an extensive railway system and used rare open-cab Neilson 0-4-0Ts, one built in 1880 and the rest in the 1890s. Seaham Harbour claimed the oldest working steam locomotive in the country namely a 0-4-0ST built by Lewin of Poole in 1863.

They were fortunate enough to be able to do the rounds of the Manchester Ship Canal before the demise of steam. Alan can never think of this concern without remembering the day when they tried to find the main depot and workshops at Mode Wheel. Their inquiries drew blank looks from the populace of the area, but they eventually tracked it down (literally!), though at one point drove into a cemetery. This was no new experience for the Rev Alan Newman, but his companions were not very amused. Places such as Stanton Ironworks at Ilkeston and Doxford's Shipyard, Sunderland, owned a stud of interesting crane engines.

On at least one occasion when the trio were visiting an industrial railway, to make a 'dead' engine look more lively, they used the strategy of introducing a lighted rag into the smoke box to make smoke.

Then there was the Bass-Worthington set up in Burton on Trent, a town plagued with a surfeit of level crossings. Alan first saw a Bass engine on an April day in 1958. In the murky and heavily malt-laden atmosphere of its surroundings, it shone like a gem. Those little beauties in turkey red and adorned with polished brass domes and

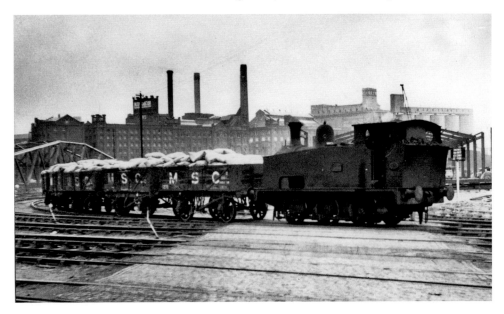

Manchester Ship Canal 0-6-0T No 64, 7 June 1966.

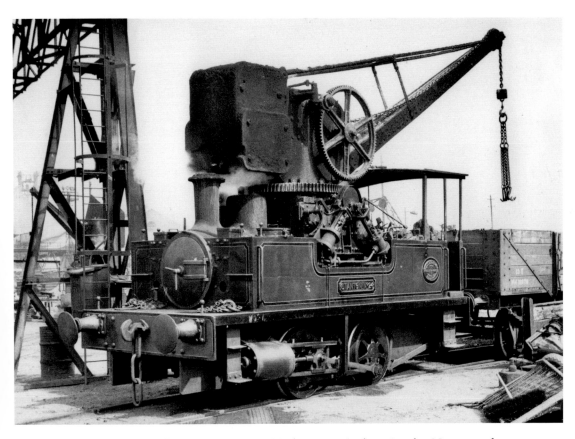

Stanton & Staveley, Ilkeston 0-4-0 Crane Tank No 24, Andrew Barclay No 1875 of 1925, 12 May 1964.

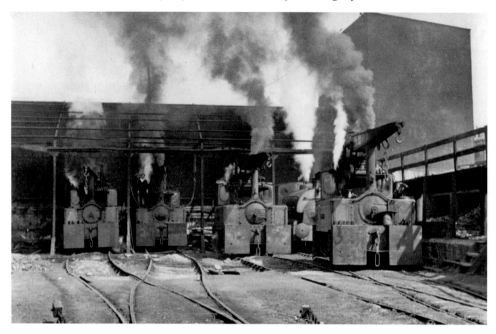

Four Crane Tanks at Doxford's Shipyard, Sunderland, 13 June 1967.

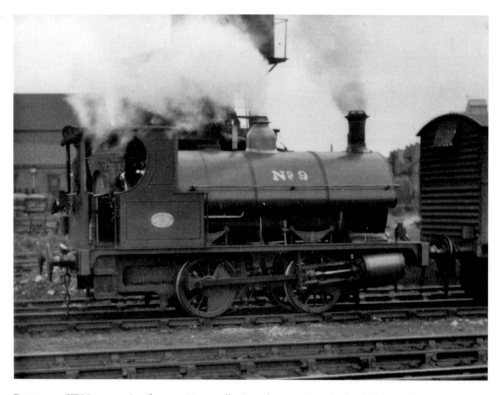

Bass 0-4-0ST No 9, 23 April 1958. Unusually, Bass locomotives had 5-link couplings.

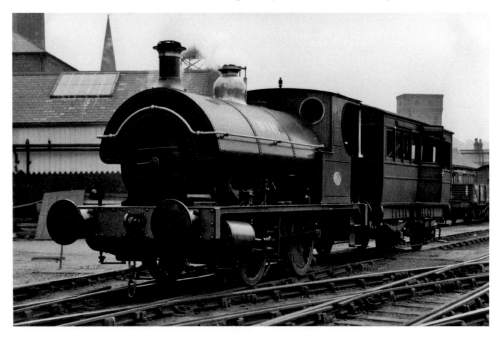

Bass 0-4-0ST No 10 with the Inspection Saloon carrying members of the Bath Railway Society, 25 April 1958.

capped chimneys were out of this world. The Worthington engines were in a different livery — an attractive blue, but not a patch in appearance or interest on the Bass engines. The Bath Railway Society, established in May 1957, Alan being a founding member, visited the system 21 May 1960. They toured the system in an inspector's saloon from which they could gloat on the lines of traffic held up by adverse crossing gates. A not unwelcome bonus on this outing was that they were given the freedom of the sampling cellars to start the day and then after the trip enjoyed a gorgeous lunch at the Midland Hotel.

In October 1964 the trio visited the Wissington factory of the British Sugar Corporation. The Hudswell Clarke 0-6-0ST *Wissington* provided the main entertainment of the day and at one time carried no less than two other priests besides Alan. One was the Rev Wilbert Awdry, then Vicar of Emneth who lived within the shadow of the Wisbech & Upwell Tramway and 'Toby the Tram Engine'. The other was the Rev Teddy Boston of Cadeby who figured largely — and literally so, for he was generously built — in their escapades of the sixties. They first heard of him during their tour of the Northamptonshire ironstone quarries in May 1960. At Cranford there was a 2ft gauge Bagnall 0-4-0ST No 2090 of 1919 bearing the name *Pixie*. Not many moons hence the Cadeby Light Railway was born and Cadeby Rectory had its very own railway. Future generations will never be allowed to forget that *Pixie* steamed within a few feet of the east end of the ancient church, for she is faithfully depicted, with Teddy on the footplate, in the fine east window.

Not having met him, the trio arranged a visit. Arriving at his house he was out. They patiently waited and he eventually arrived in his slippers driving a mud-spattered Wolseley 1500 — he had no regard for internal-combustion engined vehicles, only steam-driven ones. He whisked them off to his extensive 00 gauge railway in an ex-army hut and proceeded to run a lengthy timetable using a clock which he had

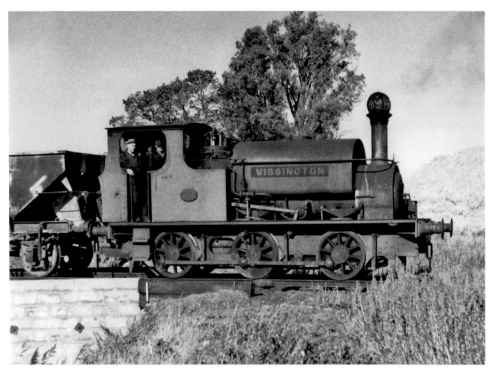

British Sugar Corporation *Wissington*, 0-6-0ST Hudswell, Clarke No 1700 of 1938, 6 October 1964.

2ft gauge 0-4-0ST *Pixie*, Bagnall No 2090 of 1919 at Cadeby Rectory, 25 April 1963. *Pixie* has a one-link coupling.

modified to run rather more quickly than normal. Eventually there was a knock on the door. A small lad came in and said 'The confirmation candidates are waiting for you Mr Boston'. 'Flipping heck!' he exclaimed and excused himself to the trio.

Whenever Alan, Ivo and Norman went out with Teddy for the day, the trio took sandwiches and were fascinated that for his own consumption Teddy brought a biscuit tin, loaf of bread and a lump of fat ham.

While visiting industrial railways in the North of England, the trio seized the opportunity to see some of the last main line steam. One day when they were at Kirkby Stephen, they met the railway photographer Derek Cross travelling on the footplate of a freight locomotive. He challenged them to reach Aisgill before his train, the road journey being less direct than the railway. Ivo sped off in his Bentley with Alan and Norman. While they were scampering from the car across fields to Aisgill Summit, Derek Cross looked out of the cab and took a photograph of them running.

Photographic Details

Alan's first photographs were taken with the family's Kodak up-market type of Box Brownie, but rather unfortunately the horizontal view finder was missing. Alan used his initiative and when out with a cousin who shared his railway interests, Alan placed his camera on that of his cousin in order to get an accurate aim. To his relative's chagrin, Alan's pictures often turned out better than those of his cousin.

Photography was out of the question during WW2 as taking pictures of trains could have helped the enemy, and in any case, film was not available. In the post-war years Alan bought an Ensign Fulvue, which did not really live up to its name because the view finder did not line up correctly. Its slow shutter speed was unsuitable for taking pictures of moving trains, so Alan purchased a folding Ensign, later replacing it with a Voightlander. His early pictures were taken on Woolworth's film purchased for sixpence, but later on in the thirties he went over to Kodak film.

Cameras Used from 1950s Onwards
Mamiyaflex, 80mm f2.8 lens
Voightlander Viyo B
Braun Paxette 45mm f2.8 lens
Praktica LTL Jena 50mm f2.8 lens
Praktica Super TL2 Tessar 50mm f2.8 lens
Canon A-1 50mm f1.8 lens

Films
Ilford FP3
Kodachrome 64
Fujichrome 100

With the closure of the S&D in March 1966, Alan began taking colour transparencies with Kodachrome, initially using a Braun Paxette, then a Practica SLR, and finally a Canon. Alan's interest in railway photography did not end with the demise of steam and he continued to take pictures of diesels, electrics and preserved locomotives until poor mobility put an end to his jaunts.